HIDDEN
HISTORY
of
FORT MYERS

About the Author

Cynthia Williams is a professional writer whose work includes creative nonfiction, fiction, narrative history, television copywriting and filmscript writing. She has published both narrative histories and creative nonfiction and has self-published part one of *The BANYAN Trilogy*, a psychological mystery whose setting is a fictionalized version of the historical Murphy-Burroughs Home in Fort Myers.

Cynthia is the recipient of a Florida Writers Association Royal Palm Literary Award for her children's story "As Wrong As Wrong Can Be" and of the Charlotte Writers' Club award for best creative nonfiction for her story "Just for Tonight."

Cynthia grew up in Fort Myers but has lived most of her adult life in Arizona and North Carolina. She now lives in Bokeelia on Pine Island, where she indulges her love of history by writing narrative histories of Fort Myers for the Sunday *Tropicalia* section of the *Fort Myers News-Press*. Cynthia also contracts with individuals and organizations to write fiction and nonfiction adult, young adult and children's books, as well as film scripts.

Much of Cynthia's published work is available on her website at www.cyn1020.com.

Visit us at
www.historypress.net

This title is also available as an e-book

HIDDEN HISTORY
of
FORT MYERS

Cynthia A. Williams
Foreword by Denége Patterson

The History PRESS

Published by The History Press
Charleston, SC
www.historypress.net

Copyright © 2017 by Cynthia A. Williams
All rights reserved

First published 2017

Manufactured in the United States

ISBN 9781467137515

Library of Congress Control Number: 2017945011

Notice: The information in this book is true and complete to the best of our knowledge. It is offered without guarantee on the part of the author or The History Press. The author and The History Press disclaim all liability in connection with the use of this book.

All rights reserved. No part of this book may be reproduced or transmitted in any form whatsoever without prior written permission from the publisher except in the case of brief quotations embodied in critical articles and reviews.

*This book is dedicated to the men and women who are the players,
the performers of the endlessly entertaining and astonishing history of Fort Myers.
We owe you a standing ovation.*

Contents

Foreword, by Denége Patterson 9
Acknowledgements 11
Introduction 13

Part I. Grey Cloud on the Caloosahatchee 15
Part II. Cattle Rustlers to Cattle Kings 37
Part III. Punta Rassa—Pivot Point of History 47
Part IV. Built on Ego 69
Part V. The Sometimes Creative Effect of Dynamite 91
Part VI. A Lost Page in Fort Myers History 101
Part VII. Out with the Old, In with the New 129

Bibliography 137
Index 139
About the Author 143

Foreword

I always need a personal connection before I am motivated to find out about the history of a place. Seven years ago, motivation came when I met a wonderful artist who had been born in Fort Myers nearly one hundred years ago. Together, we recorded her oral history and compiled a book titled *Edisonia Native Girl: The Life Story of Florence Keen Sansom, Artist Born on the Edison Estate, Fort Myers, Florida*. Now, as Florence celebrates her one hundredth year as a resident of Fort Myers, the time has come to reflect on how and why the city nurtured so many talented people like her and how it really had a good start with a cast of characters who thought "big." Since I've been busy writing a different book, *A Tour of the Islands of Pine Island Sound*, I've been wondering who besides Florence will be here to tell the story of Fort Myers to today's generation.

May I introduce Cynthia Williams, the perfect author for a modern reader. With her experience as a creative nonfiction and narrative history writer, she knows how to craft an exposé that brings history to life. Yes, her book is factual and well researched, "but wait, there's more" (she writes in a section heading with familiarity). Her intimate tone allows history to unfold in such a way that it can be voraciously devoured.

She writes with wit and irony, and she demonstrates an uncanny ability to find lustrous and relevant quotes from every era. Several delightful southern-style phrases pop up in contexts, reminding the reader how Fort Myers has always been a home in the Deep South. The book could read like a knee-slapper told on a porch, except that Cynthia Williams gives voice to different

Foreword

outlooks. Connections are made that are not found in previous histories. She deftly assembles wider and wider circles of authentic characters with boisterous commentaries of their own, and then she ties them back into her central narrative with purpose. It's all fact.

This brilliant romp shows us how the dearly departed can still be interesting. People whose last names are known only from street signs of Fort Myers are truly strategic thinkers, doers, movers and shakers propelling the advance. They are devoid of cliché. She acquaints us with people whose antics freshen the story as they express their vision, opinion and attitude about the predicaments they have gotten themselves into.

The veil of time and academia might dull portraits of historical figures, but not in this book. These personalities are premier actors in big-screen Technicolor. The book is comprehensive without being long; evocative without being manipulative; colorful without being gaudy. The account is moving, and its truth rings true.

<div style="text-align: right;">

Denége Patterson
Historian and author
*Edisonia Native Girl: The Life Story of
Florence Keen Sansom, Artist Born on the Edison Estate, Fort Myers, Florida*
*A Tour of the Islands of Pine Island Sound, Florida:
Their Geology, Archaeology, and History*
DenegeCreates.com
DenegePatterson.com

</div>

Acknowledgements

For the generous gift of their time and assistance, I wish to thank, in alphabetical order:

Erin E. Croop, marketing coordinator at Base Operations Page Field, who went way above and beyond in e-mailing photos and historical documents from Page Field archives;

Hank Hendry, great-great-grandson of Captain F.A. Hendry and an attorney who is much too busy to answer my questions but who always does;

Tim Hennigan, who worked generously and without hesitation to provide the imagery needed from his apparently inexhaustible collection of old Fort Myers photos;

Amanda Irle, my acquisitions editor, whose patience, painstaking thoroughness and unfailing kindness and encouragement have been extraordinary;

Joanne Iwinski Miller, deputy clerk in the county records office and unsung heroine of historical document preservation, for generously sharing her discoveries and eagerly helping me find needed records and resources;

John Missall at the Seminole Wars Foundation, who responded to questions concerning the confusion of post commanders during the Seminole War with patient explanations and such a wealth of supporting materials that I have the resources for another book;

Denége Patterson, author and scholar of excellent mind, with zero tolerance for sloppy research, for discussions and explorations of historical probabilities and for writing the foreword for this book;

Acknowledgements

Jim Powers, research historian at the Southwest Florida Museum of History, for allowing me to badger him for photos and information;

Ken Rager, author of the delightful children's picture book *You're a Crocagator* and generous sharer of his historical Lee County photos;

John Sheppard, recipient of the Fort Myers 2016 People of the Year Luminary Award and proud descendant of the pioneering Woolslair family, for his unhesitating and tireless sharing of the memories and family stories that breathe life into the pages of history books;

Gina Taylor, owner of the highly regarded and, yes, award-winning True Tours of Fort Myers, whose standards for historical accuracy are second to none in the history-touring business and who, when asked by The History Press to recommend a local writer, pointed to me; and

Bernie Moore, my best friend and husband, who proofs everything and never fails to find the one typo in twenty pages of text, who questions my facts and grammar, points out awkward or confusing sentence construction and locates sources for the most obscure, seemingly unobtainable historical detail, thereby perfecting and enriching my history beyond measure. His help is invaluable, his support and patience unfailing.

Introduction

I once wrote a story, titled "Falling in Love with Fort Myers," for *Tropicalia*, the Sunday magazine section of the *Fort Myers News-Press*; my story grew out of the firsthand accounts of early twentieth-century Fort Myers in Karl Abbott's *Open for the Season*. If I may quote myself, I wrote:

> To a six-year-old boy from New Hampshire, the town of Fort Myers, with its "clusters of little houses set in the lush green of the giant banyans" and "Silver King Bar and Billiard Hall with a dozen cowponies hitched to the tierack in front," seemed to possess a storybook quality. Abbott was especially taken with the merry-go-round in a vacant lot back of Frank Carson's Livery Stable. "The cowboys," he said, "were deserting the saloons to ride it."

I find the image of nineteenth-century cattle drovers hurrying through a saloon to ride a merry-go-round hilarious. I find it hilarious that there even *was* a merry-go-round behind a livery stable in the cow town that Fort Myers was at the time.

But, inexplicably, there it was.

In this detail of Fort Myers history lies, for me, the essential comedic, merry-go-round nature of human life on this planet. If you get enough distance, you see it. And with yet a little more distance, you may perceive that the hapless comedy of human endeavor is somehow endearing, even heroic. For life isn't easy. That humans never stop trying, never cease pushing against the obstructions of life to get beyond them, is heroic.

Introduction

Fort Myers began as a U.S. Army post caught between a river and a swamp. Abandoned and then reclaimed by homesteaders, it was for decades little more than a village straddling a cattle trail. The story of its exasperating, embattled, slogging progress from manured mud streets to the City of Palms is both comic and heroic; it is a story of stubborn hope and of the sheer and alarming audacity of egoism that must eternally endear humans to the gods.

As my intent has been to give the interested reader a sense of the flow of Fort Myers history in its first one hundred years, I have sketched it in broad, soft strokes. Given the obvious limitations of space, it has been necessary to omit many of the faces and voices, the events and captivating incidents—especially those related to the black community in Fort Myers—so vital to a deeper understanding of Fort Myers history. Only a fully integrated history could contain and do them justice.

The story of Fort Myers, like that of mankind generally, is not linear but circular. Very early on, like the cowboys who dismounted their real horses and mounted toy facsimiles, Fort Myers traded its wild and woolly past for a life centered on recreation and tourism, and its enterprising spirit continues unabated today. Like a carnival barker, she is still selling tickets to the show, and like a carousel whirling round and round with painted horses going up and down, she continues to fascinate.

Part I

Grey Cloud on the Caloosahatchee

As its name suggests, the town of Fort Myers, Florida, evolved from a fort. This fact is not remarkable, but the fort was. Only Hollywood filmmakers could do justice to the story of this nineteenth-century army post. The set would be expensive, the cast of characters would be impressive and the story…well, they'd have to bill it as "action-packed adventure."

The fort was established in the lull between the second and third Seminole Wars in Florida. The Seminole or Florida Wars have received little attention in historical texts, literature or film; few people know anything about them. It is little wonder that the strategic role Fort Myers played in the last of these wars should have been forgotten.

But the people and events who converged in Fort Myers between 1850 and 1858 were dramatic and decisive in moving the intermittent, four-decade-long Seminole Wars to climax and resolution.

The Florida Wars

The first of the Seminole Wars (1817–19) was an invasion of the Spanish colonies of East and West Florida by the United States to clear the way for the development of north Florida into sugar and rice plantations. After Florida became a U.S. territory in 1821 and the tide of immigration into Florida grew to include small farmers and cattlemen, a second war (1835–42) was inevitable.

Between 1817 and 1842, the Seminoles, Creeks and Miccosukee, along with remnants of other tribes in north Florida, were herded steadily southward, first from their towns and villages into a four-million-acre reservation in central Florida and finally into what the whites were calling the "Ever Glades" of south Florida. Over decades of intermittent warfare, dislocation and consequent starvation, their numbers dwindled. Time and again, given the option to either get on a boat and be deported to the Indian territory west of the Mississippi or go to a reservation in Florida and by God stay there, thousands agreed to go. Others refused.

And the settlers kept coming, pushing up to the very edges of the reservation, relentlessly pressuring the government to rid Florida of these stubborn and insolent savages.

In the summer of 1849, a group of young, renegade Indians killed a farmer on the Indian River and two traders at their store on a tributary of the Peace River. Aroused again, Florida settlers demanded protection, and the U.S. War Department responded by bringing the troop count in Florida up to eighteen companies (1,400 men) and throwing up military posts on river ways from Tampa Bay to Indian River on the east coast and to Charlotte Harbor on the west. One of these new posts was Fort Myers.

Happy Valentine's Day, Marion

On Valentine's Day, February 14, 1850, Major General David E. Twiggs, in command of all federal troops in Florida, issued an order from his headquarters at Fort Brooke: "Brevet Major Ridgely, Fourth Artillery, will take command of two companies of artillery…and proceed to the Caloosa River. He will select a suitable place for the establishment of a post and immediately throw up such light works as may secure his stores.…The post will be called Fort Myers."

General Twiggs gave the name "Myers" to the post as a Valentine's Day gift to his daughter, Marion, who was engaged to Colonel Abraham Charles Myers, chief quartermaster for the department of Florida and stationed, incidentally, with his future father-in-law at Fort Brooke. A South Carolinian of English lineage, Myers would be the highest-ranking Jewish officer in the army of the Confederate States of America.

One imagines General Twiggs inviting Colonel Myers in for a glass of brandy one evening and saying, "Colonel, I've decided to name the new post

Above: General David Emanuel Twiggs, who gave Fort Myers its name. *Courtesy Library of Congress.*

Right: Colonel Abraham Charles Myers, for whom Fort Myers was named. *Courtesy Yeshiva University Museum.*

on the Caloosa River after you. As a sort of Valentine for Marion. Call me an old fool, if you like, but I think she'll be pleased, don't you?"

The post was established about fifteen miles upriver from the Gulf of Mexico on the site of old Fort Harvie, built in 1841 and abandoned in 1842. Nothing but some fire-blackened ruins of Fort Harvie remained when Major Ridgely and his men arrived, but it was an obvious choice for the new fort. The land was slightly elevated above the swampy miasma of the Everglades, far enough from the open sea to offer some hurricane protection, and possessed a freshwater stream. And so, on February 20, 1850, Ridgeley's Fourth Artillery splashed ashore with enough supplies to make camp, ran a flag up the improvised flagpole of a skinny Florida pine and happily went fishing.

"...A Lavish and Uncalled for Expenditure of Money..."

Most Florida forts, like Fort Denaud, thirty miles upriver, began and ended as primitive pine stockades, their few structures nothing but crude log posts supporting palmetto-thatch roofs and sides. The floors of the barracks might be elevated a couple feet to keep the sand fleas away from the troopers, but that was about it for amenities. Most of the men's time was occupied in taking defensive action against the hit-and-run tactics of mosquitoes, sand fleas, horseflies and fanged insects so small they were invisible to the naked eye. Wood cutters were detailed around the clock to keep big logs of pure resin burning night and day to throw up a smoke screen against these swarming and merciless blood suckers. The men scratched until the blood ran and crusted under their fingernails.

During the sultry days of summer, after the heavy afternoon downpours, when the mosquitoes ascended in whining clouds from the steaming verdure and rivers of mud, these jungled outposts in south Florida were more akin to penal colonies than military installations. Afflicted with "Florida fever" (malaria), many died at each post.

Not so Fort Myers. Situated on the bank of the Caloosahatchee at its widest point, Marion's Valentine was to become the Riviera of the entire federal fort system.

In the uneasy quiet between 1850 and 1855, the fort experienced what can only be described as a building boom. General Twiggs at Fort Brooke sent in carpenters, laborers and brick masons with orders to construct all buildings according to plans approved by his son-in-law, Colonel Myers. To receive the building materials arriving under sail and steam from Pensacola and Apalachicola, a one-thousand-foot-long wharf was constructed with a one-hundred-foot-long pier head where boats docked and unloaded onto a tram car that ran along rails the length of the wharf into camp.

The lively sounds of trees falling, saws singing and hammers knocking wood continued cheerily for years. By 1855, fifty-seven buildings of planed pine occupied a cleared expanse along the river equal to the dimensions of a small town. The buildings included numerous houses for officers and barracks for enlisted men, administration offices and warehouses, a guard house, a blockhouse, stables, a blacksmith, a laundry, a baker's cottage, a gardener's house, a commissary and a fine two-and-a-half-story hospital. The buildings were finished with siding, doors, windows, cedar

A drawing by an officer of the military post of Fort Myers during the Civil War. Officers' quarters and barracks are along the waterfront (*left*); the path before these buildings would become the main street (First Street) of the future town of Fort Myers. Note the blockhouse at lower right and the pine tree flagpole. *Courtesy SWFL Museum of History.*

roof shingles, floors and brick fireplaces with mantels. Most aesthetically pleasing were the plastered interior walls of the hospital.

Perhaps the expenditure of $30,000 for the hospital was a bit much, for in 1856, despite the war then in progress, the War Department sent a man to investigate; the astonished major reported that "unnecessarily expensive buildings have been erected and that a lavish and uncalled for expenditure of public money has been obtained at that post, particularly for the hospital building." The major was particularly indignant that the men had thoughtfully provided themselves also with lawn bowling and a bathing pavilion.

The Principal Players Make Their Entrance

Back in 1850, within weeks of the establishment of the fort, while the men were still felling trees and attaching palmetto fronds to temporary shelters, Captain John Charles Casey, commissioner for the removal of the Seminole Indians from Florida, arrived.

An Englishman by birth, John Casey was admitted to West Point at the age of fourteen and graduated with Robert Edward Lee in 1829. His U.S. Army career included service as assistant professor of chemistry, minerology and biology at West Point; field officer and Indian agent during the second Seminole War; chief commissariat of the army during the Mexican War; and appointment in 1849 as Indian removal agent in Florida. By this time in his career, Casey was terminally ill with tuberculosis. Gaunt and pale, often wracked by a crippling and bloody cough, he was, nevertheless, a cheerful and courageous officer.

He was also on cordial terms with one of the most feared of all the warrior chiefs in Florida.

Holata Micco, Billy Bowlegs, head chief of the Seminole, was an Oconee Seminole born into the Cowkeeper dynasty, in the Alachua savannah of north central Florida. Presumably of mixed Native American and French heritage, he had given to the whites the name "Billy Beaulieu," but his Hichiti dialect perverted the French surname to "Bolek," which Americans heard as "Bowleg." Since becoming chief governor of the Seminole at the age of twenty-nine in 1839, Billy had flatly refused to discuss the deportation of his people to the Indian Territory. The alternative, which he accepted, was confinement to the promised reservation in southwest Florida. The reserve began just north of Lake Okeechobee and swung southwestward to Charlotte Harbor on the Gulf of Mexico.

Not long after Casey's arrival at Fort Myers, this stocky, square-faced man of average height, wearing leggings, a belted calico shirt and a feathered turban, strolled into the sea of uniforms at the new fort accompanied by a rather alarming number of his warrior sub-chiefs. Escorted to the fort's makeshift command post, Holata Micco and his escort waited patiently under its palmetto thatch roof, their faces striped with the bands of sunlight filtering through the palms. Post Commandant Colonel John Winder came quickly, in a noise of creaking leather boots, belt and holster, his face grim.

A native of Maryland, Winder was a West Point graduate and, like Casey, a veteran of the Mexican War. In the Civil War (1860–65), he

Seminole chief Billy Bowlegs.

would attain the rank of brigadier general in the Confederate army and be appointed commander of all the prisoner of war camps in Georgia and Alabama. The camps are notorious for the slaughter, by starvation and disease, of tens of thousands of U.S. soldiers. Winder would brag, "I am killing off more Yankees than twenty regiments in Lee's army."

In April 1850, Colonel Winder's eyes were cold as Casey introduced him to Billy Bowlegs. Winder knew that eleven years earlier, Bowlegs was one of the three leaders of the Fort Harney massacre just a few miles downriver. Billy was twenty-nine at the time, but now he was forty, resigned, and wanted only to protect his people from further hardship and heartache, and so he explained to Colonel Winder that he and his people were presently settled within their reservation lands about thirty miles southeast, that they were farming and content as they were and had no objection to the presence of the soldiers as long as they were left alone. Though Bowlegs spoke in a calm and friendly manner, there was no mistaking the threat in his words. It lay coiled, like a sun-warmed snake, in the smiling courtesy of his black eyes.

The meeting was concluded politely on both sides.

Fort Myers post commandant Colonel John Winder, who would command Confederate prisoner of war camps during the Civil War. *Courtesy Library of Congress.*

Casey and Bowlegs, Running Interference

Casey and Chief Bowlegs had been running interference between the whites and the Seminoles since the previous summer, when five renegade Creeks, Miccosukees, Seminoles and Yuchis killed settlers up on the Indian and Peace Rivers. A cycle of retribution killings leading to another war might have begun again but for the intervention of Billy Bowlegs and Arpeika, aka Sam Jones, head chief of the Miccosukee. With Casey acting as facilitator and liaison, these powerful Indian leaders met with General Twiggs, the

chiefs promising to hunt down and turn over the killers. Three were caught, one was killed trying to elude capture and the fifth escaped.

At the conclusion of the affair, General Twiggs stated that Captain Casey's "efforts have been crowned with great success.…It is a simple act of justice to acknowledge the important service Captain Casey has rendered in re-establishing, at no slight personal risk, a communication between these people and ourselves at a time when it was believed impossible by every man in this community, and thus probably averting a war otherwise inevitable."

In August, following Bowlegs's visit to Fort Myers in April, another killing occurred. This time, the victim was an eight-year-old white boy up in Marion County.

Casey and Bowlegs conferred at Fort Myers. The killers were Creeks, Billy informed Captain Casey. They had killed the boy in retaliation for the theft of three horses. Billy got word to Chipco, chief of the Creeks, to bring them in. Nearly two years later, they were turned over to Captain Casey at Fort Myers. Casey interviewed them and believed their assertion that they were scapegoats, but he had no choice but to send them on to imprisonment and trial at Fort Brooke. Six days later, the three untried men were found dead, hanging from the bars of their cell.

White settlers continued to pressure the state government and the state appealed to the federal government to do something about the Indians, but the War Department continued its efforts to resolve the problem by persuading the Florida Indians, with hefty gifts of money and goods, to migrate to Indian Territory.

Finally, in 1853, Secretary of War Jefferson Davis, a southern Democrat, slaveholder and future president of the Confederate States of America, put a new plan into effect: Indians in Florida were to be cut off from all supplies gained through trade with settlements and trading posts; a noose of forts connected by roads was to be thrown around the reservation and the noose systematically tightened with the incursion of roads and surveyors into the Big Cypress and Everglades. The intention was to let the Indians know that the land was not theirs, never was and never would be—that it was ours and we were forthwith taking possession.

"And that," Captain Casey told Colonel Winder, pausing to cough violently into his handkerchief, "will get precisely the end desired by civilians, newspaper editors and politicians in Tallahassee and Washington City."

"And what is that, Captain?"

"War."

The Noose Tightens

In January 1855, Colonel Winder was relieved of his command of the Caloosahatchee District by Colonel Harvey Brown, who arrived with his wife, Anne Eliza; daughter, Emily; and two companies of reinforcements.

A native of New Jersey, sixty-year-old Colonel Brown was a West Point graduate and veteran of the Black Hawk, the second Seminole and the Mexican Wars. In the Civil War to come, Brown would remain loyal to the United States and achieve the brevetted rank of brigadier general for "gallantry and good conduct."

And it was Colonel Brown who, in accordance with instructions from the War Department, would tighten the noose on the Indians sufficiently to initiate violent retaliation.

The Last War

In December 1855, Colonel Brown ordered First Lieutenant George Hartsuff, Second Artillery, his newly appointed topographical engineer, into the Big Cypress on a reconnaissance mission, and on December 7, Lieutenant Hartsuff led out of the fort six mounted men, two foot soldiers and two teamsters driving wagons pulled by teams of six mules each. For the next twelve days, the men and mules hauled themselves through swamp and sawgrass, mangrove and cypress roots, encountering only two Indians, who scurried into the dense underbrush to avoid them. The men were not unduly concerned when they discovered that the blockhouses the army had thrown up before the rains the previous spring had been burned to the ground. Perhaps the deserted Indian villages and overgrown gardens they found reassured them, for they camped on the twelfth night without posting sentries.

The next morning, they were saddling up to return to Fort Myers when a volley of rifle fire tore through the four men by the cook fire, killing them instantly. In the battle that ensued, two of the soldiers ran without returning fire, leaving only Lieutenant Hartsuff and three privates, all wounded and one fatally, to defend themselves against thirty howling attackers.

Five of the ten-man expedition returned alive to Fort Myers, straggling in one and two at a time over the next two days. Wounded and starving, they had dragged themselves over sixty-five miles of Florida jungle, including

alligator-swarmed swamps and rattler-infested palmetto thickets, to recuperate in Fort Myers's lavishly expensive hospital.

Lieutenant Hartsuff was one of the five survivors. With a broken arm, a severe leg wound and a bullet in his chest, and losing consciousness for hours at a time, he finally made it to the outpost of Fort Drum, guided in the darkness by the glow of the campfires and the blessedly sweet sound of the drummer playing softly on his snare drum the evening tattoo.

The Presence of a Lady

In February 1856, Fort Myers received a new post quartermaster, Captain Winfield Scott Hancock. With Captain Hancock were his twenty-four-year-old wife, Almira (Allie), and five-year-old son, Russell.

A native of Pennsylvania, Hancock was a West Point graduate who had served as a field officer in the Mexican War and later as regimental and post adjutant at Jefferson Barracks in St. Louis, Missouri, where he and Allie were married in 1850. Hancock would be a Union general in the Civil War, known to his enemies as "Thunderbolt of the Army of the Republic" and by his comrades as "Hancock the Superb." A man of whom President Rutherford B. Hayes would say, "he was through and through pure gold," Hancock ran unsuccessfully in 1880 on the Democratic ticket for president of the United States.

In 1856, Captain Hancock accepted a transfer to the quartermaster department to gain a promotion, and when he and Allie arrived at their wilderness post, they were innocent of any knowledge that war with the local Indian tribes was imminent.

Allie found her new life inconvenient at best. Supplies came in under sail once weekly, storms at sea permitting. Milk was a luxury unknown at Fort Myers, but when you are sleeping with the post quartermaster, putting in a request for a milk cow seemed not out of the question, and Allie finally got one.

Hancock's quarters, graced with the presence of a lady, became the officers' social center. While the punctual afternoon storms raged with cataclysmic thunder and lightning and deafening downpours, the men enjoyed cards, conversation and refreshment in the cheerful, lamp-lit parlor of Captain and Mrs. Hancock.

Although the Caloosahatchee River region of Florida was relatively quiet now, elsewhere in Florida, settlers were being attacked and were fleeing to

Fort Myers post quartermaster Captain Winfield Scott Hancock. *Courtesy Library of Congress.*

the closest stockades, and the army was doing battle with sometimes large numbers of Indians. In May, Fort Myers learned that fifteen Seminoles had attacked and killed two children on a farm just north of Tampa. Then a wagon train in central Florida was hit and three men killed. In June, a farm only two miles from Fort Meade was attacked. The family shut themselves up inside and returned fire until seven militiamen at Fort Meade, hearing the gunfire, came at the gallop. Three were killed and two wounded.

Additional troops arrived at Fort Myers for deployment in the Everglades. Too many for the fort to accommodate, the troops were camped about a mile outside the fort, and all that summer, the officers drew straws to decide their turns at the Hancocks' breakfast, lunch and dinner table.

But Allie was bored witless. Confined to the fort due to the presumed proximity of hostile Indians, the only recreation available for her and her boy Russell was a walk out on the army wharf or a barge trip on the river. Captain Hancock put armed men at the oars, and at the first glimpse of anything resembling an Indian, Allie and Russell lay down under a heavy tarp until the danger was past.

The only other diversion, and not a welcome one, was to be awakened in the middle of the night by a long drum roll, the signal for an impending attack. A dash in bedclothes and boots to the blockhouse, without lights of any kind, was inevitably a pointless exercise, as the alarms were always triggered by drunks trying to crawl undetected under the ten- to twelve-foot sentry platform. Some of them were shot and killed in the attempt.

The Pious and the Profane

Brigadier General William Selby Harney, the "Bengal Tiger."

In November 1856, Colonel Gustavus Loomis assumed command at Fort Myers of troops in the Caloosahatchee District. A native of Vermont and a West Point graduate, sixty-eight-year-old Loomis was a veteran of the War of 1812, the Black Hawk War, the second Seminole War and the Mexican War. During the Civil War, he would serve the United States as a recruiting officer.

In the same month, Brigadier General William S. Harney assumed command at Fort Brooke of all federal troops in Florida. General Harney and the Hancocks were acquainted. General and Mrs. Harney had given the Hancock newlyweds a wedding reception in St. Louis.

A native of Tennessee, General William Selby Harney was commissioned a second lieutenant in the U.S. Navy in 1817. He had served in the infantry under General Andrew Jackson, as a major in the paymaster corps at Jefferson Barracks and attained the rank of brevet brigadier general in the Mexican War. While serving as a brevet

major general in command of federal troops in Texas, and incidentally, while on leave in Paris, General Harney was sent to Nebraska Territory to lead a punitive expedition against the Lakota (Sioux) Indians. From the Lakota, Harney earned various titles, including "mad bear," "butcher" and "woman killer." An exceedingly punitive-minded man, he slaughtered eighty-six Lakota men, women and children who had come to him under a white flag of truce. In the Mexican War, he hanged thirty Irish Roman Catholic captives, including one who had had both legs amputated the day before. Twenty years earlier, then Major Harney had to flee Missouri when threatened by an enraged mob over his having whipped a female slave to death.

Harney's troops called him the "Bengal Tiger."

The Tiger Is Back

The Seminoles had the bitter taste of Harney in their mouths, also. In revenge for the massacre of his command at Fort Harney (present-day location of the Cape end of the Cape Coral Bridge) in 1839, a surprise attack that Harney survived by jumping in the river and swimming for dear life in his underwear, he had later tracked the attackers to their presumed village in the Everglades, giving the order before the attack to kill every Indian in the village. When the battle was over, the surviving warriors, who had fought to defend their families, were summarily hanged.

General Harney added seven mounted companies to the troop strength in Florida, sending them to outposts in a line from Fort Brooke in Tampa to Fort Capron on the Atlantic and at all major river crossings and sending one into the Everglades. His intention was to drive the Indians deep into the Glades until the summer rains and rising waters drove them out. As the army cut trails into the reservation, they planted white flags as invitations to surrender talks, but the Indians pulled them up and tossed them aside.

The Tiger Unleashed

Fed up with waiting for Indians to surrender to soldiers in the field, General Harney unleashed his men with orders to pursue, capture or

kill Indians off or on the reservation. Time and again, troops advanced on villages only to find the chickees, the crops in the field, the harvested food stores and the hogs and cattle abandoned. The troopers managed now and then to bring in a few women and children, whom Harney violently harangued, demanding to know the precise location of Billy Bowlegs's village. Little Russell Hancock was present the day General Harney brandished a rope in the faces of his female captives, threatening to hang their children if they did not give away Bowlegs's whereabouts. The man's rage was lunatic, and when he grabbed a child and dropped a noose around his neck, Russell was so frightened that he began to weep, begging the general not to hang him. Convulsed with sobs, he shrugged off the restraining hand of his father and pleaded, his small fists balled at his sides, but the general proceeded to tighten the noose slowly, watching the face of the child's mother. In the moment's impasse, Russell's shoulders plunged, and he dropped his head in defeat. "Well," he murmured tearfully, "if you're going to hang them, at least let me have their bows and arrows."

Even the corners of General Harney's mouth twitched, and when he guffawed, all the assembled officers shouted with laughter. That was the end of "negotiations" for that day.

A daughter, Ada Elizabeth, was born to the Hancocks in February 1857. Two months later, General Harney was transferred to Fort Leavenworth, Kansas. He requested that Captain Hancock be assigned with him, and so the young couple, with their new baby, boarded a steamship at the wharf and departed, grateful to escape the stresses and discomforts of Fort Myers.

Colonel Loomis also left Fort Myers in April 1857 to assume General Harney's command at Fort Brooke. Oddly enough, he was missed. For months, the old man's quavering voice had drifted in hymn song, morning and evening, from the open windows of his quarters. The scripture-reading, psalm-singing old man was in such comical contrast to the vile-tempered, cursing General Harney, who was often in residence, that when they heard him singing, enlisted men had bent double, snorting with laughter. But now they kind of missed the homey feeling the old man's hymns had given them.

The Showman

One day in the summer of 1857, a horseman appeared at the entry of the log-and-earth breastworks that formed a semicircle of the fort's vulnerable east, south and west perimeters. He was a white man, wearing leggings and a shirt with a colorful sash and a broad leather belt. His shot pouch, like his moccasins, was heavy with bead work, and his turban was adorned with egret feathers. As his horse, prompted by a slight nudge of the man's heels, began a stately walk onto the grounds of the fort, men came running out of the buildings, from the waterfront, the stables and every other corner of the compound.

In procession behind the man on horseback were nine captive Indian women and six children, some babies in slings on their mothers' backs. Trailing the captives were a company of Florida volunteers. Lean as jerked beef, jaundiced, many of them very nearly toothless, they plodded along in blood- and mud-stained butternut suits, their thin hair hanging in greasy strips from under the broad brims of shapeless felt hats.

"It's Mickler," one of the officers murmured, and the name went around the assembled gape-mouthed garrison.

The officer who recognized Mickler had seen him before. Jacob Mickler had been a guide for Company C out of Fort Center up near Lake Okeechobee. He had made his first appearance there in a wide-brimmed white felt hat, a blue flannel shirt and bright blue overalls tucked into knee-high boots. With a rifle over one shoulder and casually eating an orange out of his other hand, he had asked for the officer in command of the post.

The major in command of Company C, to which Mickler was assigned as scout, took a strong dislike to the man's charismatic nonchalance. Out on Lake Okeechobee one day, on patrol for Indians, he had refused to let Mickler out of the boat to track some Indian sign on an island in the lake. Mickler pulled a gun and forced the officer to put him ashore. The last time Company C saw him, he was walking off into sawgrass with his haversack over one shoulder and his shot bag and rifle over the other.

Mickler walked one hundred miles back to Fort Brooke and reported the incident to the commanding officer, telling the officer that if he wanted the Indians out of the Glades, he'd better give him his own company. He got it.

Mickler was not a big man, but he was strong, tough as an Indian. He could spear a rattlesnake with one thrust, and though he enjoyed shooting alligators point blank in the head from a canoe, he was a dead shot at any distance.

He was also a first-rate poker player. He got up a game in every camp, raking in his winnings with a quiet smile. It was said he sent the winnings to his mother in St. Augustine.

The men of Company C, whom Mickler had walked away from at Lake Okeechobee, marched into Fort Brooke one day and were resting in the shade of a big oak when an elegantly attired gentleman approached. He wore a suit of white flannel, a large Panama hat and a rather splendid diamond solitaire. His black hair and mustache were neatly trimmed and shone as brilliantly as his patent leather shoes. When he smiled, the men recognized him at once and jumped to their feet with boisterous greetings: "Mickler, you son of a gun, how are you!"

And now here he was again, entering Fort Myers with his captives and "army," in perfect burlesque of a Roman conqueror's triumphal procession into Rome.

His captives were, with one possible exception, amenable to their captivity. Mickler and company had discovered them in a hammock on the Kissimmee River near Lake Okeechobee. They had simply surrounded the women and children and walked in. All but one woman, whom they had to carry kicking and screaming to the canoes, came along agreeably. In fact, on the journey to Fort Myers, captors and captives enjoyed a bear roast that most particularly delighted the women. At Fort Myers, while Captain Casey looked on with a grin, the women shook hands with and spoke a heartfelt goodbye to each man in Mickler's company.

But they were heartbroken to discover that their own men were not there to greet them. They had come willingly in the expectation of finding their husbands already captive in Fort Myers. Mickler reported, "When we left they were wandering to and fro, crying together like children."

The Final Sweep

The previous spring, the War Department had begun withdrawing troops from Florida. Indian wars out West and the war in Kansas between pro- and anti-slavery forces required a buildup of federal troops in the territories. Left with only four companies of infantry in Florida, Colonel Loomis at Fort Brooke had sent them to Fort Myers and positions south. The War Department ordered into federal service ten companies of militia commanded by an attorney from Ocala named S. St. George

Rogers. Taking command at Fort Myers in October, Colonel Rogers sent five companies to Fort Denaud and brought five to Fort Myers, bringing the troop strength under his command to thirty-three officers and seven hundred men. The final sweep of southwest Florida had begun.

Decimated in number, hungry, some reduced to prying spent lead out of trees to use for ammunition and constantly on the move, the surviving Seminoles, Miccosukees and Creeks nevertheless kept up the best-organized resistance they could. Patrols were attacked, soldiers killed and ammunition taken.

The army regulars and militia had their own peculiar problems. Their weapons were so antiquated that some muskets wouldn't even fire. Volunteers, organized into "boat companies" of forty-five men each, who were to pursue the Indians in the swamps in flat-bottomed boats, knew nothing about boats and proceeded clumsily, knocking oars with one another. Incessantly slapping and cursing mosquitoes, many sickened and died from malaria.

A Rising Tide

Nevertheless, in November, the tide of the war turned inexorably against the Indians. From Fort Myers, Colonel Rogers deployed and led his own army of regulars and militia into the Big Cypress. Advancing steadily, his small army killed when attacked, took captives and destroyed hundreds of acres of crops and whole settlements of chickees and storehouses filled with many hundreds of bushels of food stores. They took or destroyed livestock—hogs, oxen, cows—and, in one raid, carried away the prize souvenir of a tintype of Billy Bowlegs made in Washington City during his visit to the capital in 1852.

The militia pushed ever deeper into the Glades, staggering through waist-deep swamp water, muskets lifted as if in surrender. They shouldered their way through dense, razor-sharp sawgrass, pushing with all the strength left in their malaria-ridden bodies under an infernal sun that consumed, in brilliant and absolute stillness, the very oxygen in the air. They screamed curses in the day and, in a stupor of fatigue, slept in trees at night.

Their few captives were as numb with exhaustion as the soldiers. Some admitted that they were glad to be caught. They were sick of wet feet from

swamp-running. One ancient said quietly, however, that he would never leave Florida alive, and while camped at Punta Rassa on their way to Fort Myers, the old man managed to shatter a glass bottle and swallow the glass shards before they could stop him.

The captives were mostly women, children and old men. When brought to Fort Myers, they were given the run of the place. The kids romped around the expansive parade ground or annoyed the soldiers in their barracks by wrapping their arms around the men's legs and begging them for rides on their shoulders. Perhaps Colonel Rogers complained to Colonel Loomis about the growing numbers of Indians in the fort, for Colonel Loomis came up with a plan satisfactory to all. He selected Egmont Key, a two-mile-long, one-quarter-mile-wide island at the mouth of Tampa Bay, to use as a sort of prisoner of war camp in paradise and had all the captives in Fort Myers shipped up there. Deprived of the fresh seafood they had enjoyed before the war, the Indians could now fish and go clam digging to their hearts' content. Every incoming boatload of captives was eagerly met, the captives weeping, shouting and dancing for joy when reunited with friends and family. The soldiers on the boats watched their unrestrained glee with broad grins.

Surrender

In the early winter of 1858, Colonel Loomis was instructed to halt all offenses against the Indians in Florida. All patrols were ordered in, and white flags were displayed around the fort. A delegation of forty Seminoles and three Creeks from the Indian Territory; three women from Egmont Key; the Seminole and Creek agents in Oklahoma; and Elias Rector, the superintendent for Indian Affairs for the Southern Superintendency, were arriving at Fort Myers in February to try to persuade, yet again, the die-hard Florida Seminoles still resisting deportation to get on the damn boat. Powerful inducements were offered, including self-government on a two-million-acre reservation and hundreds of thousands of dollars in reparations and resettlement expenses.

After arriving in Fort Myers, this assemblage rested in a riverside encampment just east of the hospital (at the approximate present-day location of the Burroughs Home) and then fanned out into the Everglades. The officers and men garrisoned at Fort Myers waited.

On February 22, the word they had been hoping for arrived. Two envoys from Billy Bowlegs had contacted Rector. Rector was arranging a meeting. He requested that all volunteer militia be withdrawn from the area selected for the meeting.

And thus began, in March 1858, the series of meetings with Billy Bowlegs some thirty-five miles southeast of Fort Myers that finally ended over forty years of intermittent warfare with the Indians in Florida.

Superintendent Rector said of Bowlegs later that "he is a personage with whom little can be done without money and nothing without plain speaking." Indeed, only after an arrangement had been made that gave thousands of dollars in damages and relocation costs to each of his people did Bowlegs agree to so much as take the proposition to them.

Two weeks after departing the last council, Holata Micco returned. His people were coming in.

Billy's Creek Camp

The army sent out wagons to help bring in the nearly starved Seminoles. A camp was set up for them on the bank of a freshwater creek about a mile north of the fort (present-day site of the Old Fort Myers Cemetery). It took weeks for word to reach everyone hiding in the Glades and Big Cypress that the war and the diaspora were over and more weeks for them to straggle on in.

Before daybreak on the morning of May 4, 1858, the women in the Indian camp on the creek were breaking twigs for fire tinder, and soon fragrant wood smoke spiraled from their small cook fires. Some of the women made breakfast; others packed and fed the kids and old men. They ate silently, then doused the fires, shouldered the babies and what few belongings they had, looked back and up into the sunlight just filtering through the branches of the trees and then turned and began their walk to the river. When the last had shuffled from sight, only the lingering smoke of their fires drifted with the morning mist over the stream that ever afterward would bear the name "Billy's Creek."

Grey Cloud on the Caloosahatchee

Colonel Loomis had sent his steamer, *Grey Cloud*, for them. As the thirty-eight men and eighty-five women and children, led by Billy Bowlegs, walked onto the steamship, they turned to grip the railing, their eyes turned landward until the ship passed Punta Rassa. Trailing a grey cloud of steam, the ship was soon lost in the vastness of the Gulf of Mexico.

Part II

Cattle Rustlers to Cattle Kings

Months after the last militiaman swung into the saddle and kicked his horse into a canter out of Fort Myers, a small group of Seminoles walked in. They came quietly, pausing at the sudden realization that the fort was empty. They had come to surrender. They had wanted to get on the boat, to find their families in Indian Territory. Gazing about forlornly at the abandoned compound, which for nearly a decade had been the bristling fortress of the enemy, their hearts may have felt as hollow as the deserted buildings around them. Finally, all they could do was turn and go back into the wilderness, leaving behind them only the dragonflies that darted in silent, erratic flight about the sun-bright parade ground.

But five years later, in 1864, the army wharf reverberated once again with the clunking of boots. The soldiers were back. But these soldiers were not like the others. Instead of white linen roundabout jackets and black leather forage caps, they wore blue wool sac coats and kepis. They were a company of the 110th New York Infantry, the Second Florida Cavalry (made up of Union sympathizers), and Company I, Second Regiment United States Colored Infantry.

They had come to rustle cattle.

Feeding the Army

Since the beginnings of white settlement in Florida, raising cattle had been favored by many as the surest way to survive, even to prosper, in this warm and fertile new territory of Florida. The Indians had enjoyed ownership of large herds, upon which the white settlers preyed, so that by the time the Indian wars in Florida (1817–58) were officially ended, Florida numbered more cattle per person than any other state east of the Mississippi.

In 1845, the twenty-seventh star was added to the U.S. flag when Florida joined the Union. Sixteen years later, Florida left the Union to join the Confederate States of America. In the war between the USA and the CSA, Florida's foremost role would be to provide the Confederate armies with the meat, tallow and hides of beef cattle.

Cattle king Jacob Summerlin. *Courtesy SWFL Museum of History.*

At first, Florida ranchers were happy to see Confederate commissary agents ride up waving army contracts. They signed gladly and ran thousands of cows to railheads in north Florida for shipment to the armies of the Confederacy.

One of the cattlemen who contracted with the Confederates to supply beef was a wealthy rancher by the name of Jacob Summerlin. Born in Florida within months of its purchase by the United States from Spain in 1821, Summerlin received, as a young man, a princely inheritance of twenty slaves, valued at $1,000 each. Summerlin was no fool; he traded the slaves for the six thousand head of cattle that would seed a cattle empire in Florida.

During the Seminole Wars, Summerlin was buying and selling cattle by the thousands, driving herds from central Florida north to St. Augustine on the Atlantic and south to Punta Rassa on the Gulf of Mexico. From Punta Rassa, he shipped his cattle two hundred miles south to Havana, where he sold them at a profit of four to nine dollars a head. When asked to sell some of his beef to the Confederacy, Summerlin signed on proudly,

and between 1861 and 1863, he shipped twenty-five thousand head to the Confederate army in Georgia.

These cattle drives did not escape the attention of the United States Army. The War Department responded by sending troops to occupy Fort Myers, just sixteen miles upriver from Punta Rassa. The troops deployed there were to *redirect* the cattle that Confederates were running north to Georgia, south to federally garrisoned Key West.

Profiteers, Pioneers and Patriots

Gradually, the herds of cattle driven to Georgia thinned. The patriotism of Florida ranchers had waned with the realization that the currency they received from the CSA for their cattle had a rather low rate of exchange.

In Havana, however, the Cubans were paying, not eight or ten dollars a head in paper, but thirty dollars a head *in gold*. The trick was to get the cattle to Cuba. As part of the Union's Anaconda Plan to strangle the Confederacy by blockading its ports from Virginia to Galveston, U.S. naval vessels were blockading Boca Grande pass to prevent the smuggling of cattle and cotton to buyers in the Caribbean. But Jacob Summerlin was the quintessential pioneering empire builder; no obstacle, be it swamp, river or war, would stop him from driving his cattle to market. Having moved his herds down into the Peace and Kissimmee River region, he herded the cows onto blockade-running vessels hidden along the coast and at river inlets around Charlotte Harbor. His first shipment of six hundred head earned him $18,000. He and his partners became commodities traders, bringing back fabric, shoes, salt, flour, sugar, tobacco and medical supplies, which were either sold at staggeringly inflated prices or traded for cattle.

To Florida settlers, the blockade runners, who smuggled in to them food and other necessities that could not be had by any other means, were heroes. If one needs food and selling cattle in Cuba rather than to the Confederacy will get it for you, then profiteering blockade runners are patriots, no matter what anybody says.

Severely Annoying the Rebs

A Georgia-born slave owner, cattleman and agent for the Florida Commissary by the name of Francis Asbury Hendry described events at Fort Myers during the war:

> *Frequent and destructive raids were made far into the interior and into Confederate lines, causing much distress to the devotees of the Southern cause. Large herds of cattle were rounded up by Federal cavalry and driven to Fort Myers and there slaughtered for use by the garrison, and the blockading squadron of Sanibel island in San Carlos bay, and a large number carried on transports to Pine Island, landing about where St. James is now situated.*
>
> *So annoying was the condition that an unsuccessful attempt was made by Colonel C.J. Munnerlyn's battalion, commanded by Major William Footman, to capture and destroy the place.*

A Little Unpleasantness

Charles James Munnerlyn was a slaveholder (his slaves numbered in the hundreds) and a Confederate congressman who joined the army when he lost his seat in the Confederate Congress in 1863. CSA president Jefferson Davis commissioned him a major with orders to organize a regiment whose mission would be to keep open the cattle supply line from Florida to the Confederacy. Munnerlyn was to prevent raids on cattle herds by the Federals out of Fort Myers, to stop cattle rustling by thieves, to protect the salt works along the Gulf coast and to assist Confederate blockade runners. He formed the First Battalion, Florida Special Cavalry, ultimately nine companies of eight hundred men, consisting largely of cattlemen who had been exempted by the CSA from military duty because each owned five hundred head or more of cattle. Wisely, the CSA much preferred to keep these men home guarding the Florida beef commissary to throwing them into the mouths of U.S. cannons.

By 1865, this "cow cavalry" had found the Federal cattle raids sufficiently bothersome to attempt an attack on Fort Myers. The rumor going around was that troops were being withdrawn from the fort, but Major Footman was to discover that the rumors had been greatly exaggerated.

On the night of February 19, Footman ordered F.A. Hendry, who commanded a company in the cow cavalry, to detail ten of his men to capture the Federal pickets (and their prize Enfield rifles) posted on Billy's Creek. They really did try, but in the pitch darkness and hammering rain, they couldn't find the picket post, much less attack it. They came riding into camp out of the fog the next morning, as sodden and dejected as their horses.

Major Footman then summoned Captain F.A. Hendry's cousin Lieutenant W. Marion Hendry to pick ten of his own men to find and charge the post.

The cavalry charged the astonished sentries, and though some accounts say that three were killed, according to Captain Hendry, they were brought "trotting back to the rear in a few minutes." Hendry does not relate the subsequent fate of these prisoners of war.

Meanwhile, back at the fort, officers and men, who had been sufficiency alerted by the sound of gunfire not to doubt its meaning, were doubly surprised to find themselves fired upon by a cannon outside the seven-foot-high log and earthen breastworks of the fort. Peering out from the blockhouse, Captain James Doyle, in command, watched in amazement as a rider approached the fort with a white cloth hanging from the muzzle of his musket. Presently, a sentry came to him with the message that he had twenty minutes to surrender Fort Myers to the 275 assorted cattlemen, old Indian fighters and settlers ranged before them.

Possibly with lifted brows and an expression of wonderment, Captain Doyle politely responded, "Your demand for an unconditional surrender has been received. I respectfully decline."

Receiving his reply, the messenger spurred his horse back to Confederate lines and wheeled about beside the field piece that had been drawn up facing the fort. Shoving the "flag of truce" off his rifle into the mud, he set the rifle butt on his thigh and waited.

Movements within and without the fort were rapid and decisive. Cattle were corralled, men formed and sent to battle stations and three cannon brought up. At the twenty-minute mark, Major Footman nodded to an artilleryman, who eagerly stepped forward to light the fuse of their cannon. The Battle of Fort Myers began.

It went on for hours, with cannon and small arms fire. Captain Doyle may have sighed over the futility and waste of the exercise. Surely the Confeds knew that, even should they breach the fort's defenses, his men would fight to the death before they surrendered. Surrender for the white officers meant execution and for the black soldiers either execution or a return to slavery.

After the Battle of Olustee, Florida, one year to the day earlier, Confederates had been so intent upon slaughtering the wounded colored soldiers that they had let the white soldiers escape. Despite the Confederates' assurance that the surrendering garrison would be treated as prisoners of war, no man in the fort would risk a repetition of the carnage at Olustee.

Reports of the casualties of the Battle of Fort Myers are three Union soldiers and forty Confederate killed. It is said that the Confederates kept shifting the position of their field piece; it *would* be difficult to stay within killing range of the fort and not be hit by return fire.

Late that afternoon, the firing ceased. The Confeds had either run out of ammunition or hope or both, for they fell back and rode off, pulling their artillery piece with them.

Three weeks later, the troops occupying Fort Myers were recalled to Key West. The war effectively ended the following April 12, when the Army of Northern Virginia surrendered to the Army of the Potomac, and the Confederate states were dragged back into the Union (leaving heel tracks still visible today).

THE IRONIES OF HISTORY

History is full of irony, and the history of Fort Myers is rich with it. For instance, only a few years after Union troops were withdrawn from the fort, some of the Confederate cattlemen who had tried and failed to drive them out moved in, bringing with them the very cattle that the soldiers had wanted to capture. These former cow cavalrymen, namely the Hendrys, moved with their families into the officers' houses and turned the cattle loose in the post gardens.

The affable Captain F.A. Hendry, formerly of Munnerlyn's Cattle Battalion, had a certain fondness for the fort. In fact, he gave us the only good description we have of it. While serving as a guide for the U.S. Army during the Seminole Wars, he had visited Fort Myers and was clearly awed by it:

> *Fort Myers in that day was a veritable oasis in the desert....The walks...in and around the garrison, around the parade grounds, were shelled with carefully selected shell, not from the common oyster shell banks and bars, but shells from the seashore—the most beautiful. The parade grounds were the most attractive. Except for the shell borders, the*

most beautiful grass lawn, all kept immaculately clean. The long line of uniformed soldiers, with white gloves and muskets as bright as new coin; officers, too, with their golden epaulettes and burnished sidearms… were grand and magnificent to behold. Their quarters within were the very personification of neatness and cleanliness. The large commissary and sutler's store were well filled and tastily stored. The wagon yard and stables were exceptionally well kept, and the horses, mules and milch cows were as fat and sleek as corn, oats and hay could make them, and all were groomed to perfection. The garrison garden was cared for by expert detailed gardeners, and supplied the wants of the garrison with as fine vegetables as man ever ate.

Hendry tells us that he was handsomely wined and dined "with…noble men," noting, "The officers and men were very courteous and kind and a more comfortable and happy set of men I never saw."

Hendrys in 1909, posing with their new Cadillac. *Left to right*: George Washington Hendry, brother to Captain F.A. Hendry; Mary Jane Hendry Blount, sister to F.A. and wife of Jehu Blount; William Marion Hendry, brother to F.A.; James Edward Hendry Jr., F.A.'s grandson; James Edward Hendry Sr., F.A.'s son; and Captain Francis Asbury Hendry, "Cattle King of South Florida" and, arguably, the "Father of Fort Myers." *Courtesy Harry O. "Hank" Hendry, Captain Hendry's great-great-grandson.*

It is one of the priceless ironies of local history that F.A. Hendry, the young man who so admired Fort Myers, the army post, would become known as the "father of Fort Myers," the town. But so he did, for when he joined the several families homesteading the site after the Civil War, his brothers and sisters and their families came with him, and the Hendry clan became, well into the next century, arguably the most powerful developers and civic leaders of the growing town.

Like Jake Summerlin, F.A. Hendry had profited from the war in cattle. After the war, he continued to profit from the cattle trade with Cuba until, by 1880, he was deemed the "cattle king of south Florida," with herds totaling possibly fifty thousand head.

Hendry's power and popularity apparently grew in proportion to his cattle holdings. In the mid-1870s, he served as a state senator. In 1885, he was a dominant player in the incorporation of Fort Myers as a town and served on the first town council; it was upon his motion that the new county, of which Fort Myers became the seat, was named "Lee County" after his hero, Robert E. Lee, and he served on the first county commission. From 1893 to 1904, he represented Lee County in the state legislature.

But Wait, There's More

F.A. Hendry's reputation as the father of Fort Myers might legitimately be challenged by the descendants of Manuel and Evalina González, who were the first homesteaders on the site of the abandoned fort. Manuel was a native of Spain and Bahamian-born Evalina a descendent of loyalists who had escaped the American colonies in rebellion against British rule in the eighteenth century. During the Seminole Wars, Manuel had run mail and supplies in his small sloop from Cuba to Fort Brooke at Tampa and to Fort Myers on the return. Manuel was the young man with the broad grin whom the soldiers ran out on the post wharf to greet, eager as puppies for the treasures he brought to them twice monthly—Cuban cigars and whiskey, canned delectables like peaches and cherries and mail from home. Less than a year after the last Union troops left the fort, young Manuel was back with Evalina and his two small children to become the first settler of the future town of Fort Myers.

Manuel Antonia González, first homesteader on the site of the abandoned military post of Fort Myers. *Courtesy SWFL Museum of History.*

The Sweetest Irony of All

The reader may recall that in the summer of 1856, only six months after the attack on Lieutenant Hartsuff that precipitated the third Seminole War, a farm up near Fort Meade was attacked by Indians, and three of the militiamen who rode to the rescue were killed. The farm was owned by Willoughby Tillis.

In 1866, eight months after the González family arrived to homestead Fort Myers, settlers Nelson Tillis and his wife arrived. Nelson Tillis, born of a Tillis slave woman, was the son and former slave of Willoughby Tillis.

The first homesteaders in Fort Myers, therefore, were of Spanish, English and African descent; that is, they were Americans.

Nelson Tillis, freed slave and first African American to homestead Fort Myers. *Courtesy SWFL Museum of History.*

Part III

Punta Rassa—Pivot Point of History

The Caloosahatchee River flows by historic downtown Fort Myers in a southwesterly direction for about sixteen miles before it enters San Carlos Bay; winds around the barrier islands of Pine Island, Sanibel and Captiva; and loses itself in the Gulf of Mexico.

At the mouth of the river, on the last bit of the mainland fronting San Carlos Bay, are high-rise condominiums and the Sanibel Harbour Marriott Resort & Spa, with an exclusive (members-only) marina. Imagine swimming pools and palm trees, restaurant terraces and tropical cocktails, a mini cruise ship at the dock and sleek, outrageously expensive speed boats slicing shimmering white wakes across the bay. The scene is picture-postcard Florida.

How odd, then, that the name of this place should be the very prosaic "Punta Rassa," a derivation of the Spanish *Punta Rasca*, which is reliably translated as "Cold Point." We can only presume that the Spanish mariner or cartographer who named this punta of land a half millennium ago first visited it on a brisk, blustery day typical of March. In fact, it may have been cold enough to make the man's eyes water and his nose run.

Because Punta Rassa is situated at the mouth of a river that is a great highway into the interior of Florida, and because it possesses natural, deep-water anchorage, boats of every description, from Paleo Indian canoes to U.S. naval vessels to pontoons filled with tourists, have been converging on this spot for more than a millennium. And as the Spanish explorer with the head cold would tell you, so have cold and warm

weather fronts. In fact, it was an October tempest, whirling on the pivot point of Punta Rassa, that set in motion the events that would spawn the military post that became a city.

The Hurricane

In 1838, during the second Seminole Indian War, the United States established a fort at Punta Rassa. Three years later, the hurricane of 1841 removed it. The floodwaters, receding with the broken timber and military stores of Fort Delaney, took with them the drowned bodies of two men of the Eighth Infantry.

Receiving word of the devastation, Colonel W.J. Worth, in command of Florida troops at Fort Brooke, ordered the officer in charge to proceed upriver and find a more suitable site for a fort.

A broad hammock, canopied with old, moss-laden oaks and fragrant with pines, about sixteen miles upriver, seemed ideal. Far enough inland to have escaped the full fury of wind and waves in the hurricane, slightly elevated above the swampy Florida muck and blessed with a freshwater stream, it was as good a place as any.

So the soldiers swung their axes to the pines, and up went a barracks, a storehouse and a small infirmary. Captain McKavitt named the post Fort Harvie after one of his young officers who had died in September of malaria.

Three and a half months later, in late March of 1842, the Eighth Infantry was overjoyed to receive word that they were being withdrawn. By then, most of the Indians in Florida were either dead or deported. The war was over.

Survivors among the Seminoles may have celebrated by torching Fort Harvie, for when the U.S. Army returned in 1850, the remains of the fort were fairly lost in the overgrowth. As we have seen, however, a new fort rose from the ashes of the old and was named Fort Myers by "an old fool" of a father as a Valentine's Day gift to his teenage daughter.

The Sailor

After two more wars, Fort Myers was abandoned as a military post for good. Scavengers made off with everything that wasn't nailed down and nearly everything that was, including the nails.

And then, on a February day in 1866, Manuel González, the trader who had run supplies from Key West to Forts Brooke and Myers during the Indian wars, tied up his sloop to the army wharf and stepped out. His brother-in-law, John Weatherford, handed five-year-old Manuel out of the boat to his father. For hours, the child had been pestering his father with, "Are we there yet, Daddy?" Now Manuel smiled down at his boy and said simply, "*Estamos.*" We're here.

The Cowboys

Fort Delaney begat Fort Harvie, which begat Fort Myers, and now the Bahamian wife of a Spanish sailor was pulling weeds from the overgrown post garden while her husband knocked together the first trading post in a settlement that would be called, by default, Fort Myers.

In the meantime, Punta Rassa was busier by far than the little settlement of homesteaders upriver. The bawling of cattle carried over the water a good distance from the point in every direction.

In 1864, during the Civil War, the U.S. Army had built a wharf, barracks and cattle pens at Punta Rassa. They were driving captured Confederate cattle out there and shipping them to the U.S. base in Key West. After

The Union army barracks at Punta Rassa that became the Shultz Hotel. *Courtesy SWFL Museum of History.*

the war, herding his steers through Fort Myers and out the army trail that paralleled the course of the river to its mouth, Confederate blockade runner and war profiteer Jake Summerlin found the facilities at Punta Rassa convenient to the resumption of his lucrative cattle trade with Cuba.

The drovers who pushed Summerlin's cattle into the corrals at Punta Rassa bunked in the army barracks, a one-hundred- by fifty-foot building on fourteen-foot-high stilts. For relaxation, these men gathered underneath the barracks to drink and play poker. Cuban *aguardiente* is a spirited beverage. In an excess of exuberance, the cowboys often drew their pistols and fired into the air, thus riddling the floors of the building above them with bullet holes. With the bullet holes and the breezeway that halved the building, the barracks was an airy old structure.

The Telegraph

And then the strangest thing happened. Incongruous to its postwar incarnation as a bullet-riddled cattle station, Punta Rassa now assumed a new persona; in 1867, a telegraph cable was run from Lake City, Florida, to Punta Rassa and from there undersea to Key West, from whence, with the help of U.S. and Spanish steamships, the cable was played out by England's 1,200-ton, schooner-rigged steamship *Narva* all the way to Havana. By authority of the State of Florida and the federal government, the cable company took possession of Punta Rassa for its cable station, and Punta Rassa became a critical link in the incipient age of twentieth-century communications technology—a relay station for the International Ocean Telegraph Company (IOTC), precursor of ITT.

In time to come, the tap dancing along this line would alert the world to the presence here of some of the greatest fishing grounds in the world. The effect on Fort Myers would be transforming.

The Telegraph Operator

Jake Summerlin obligingly gave the IOTC station elbow room by building his own wharf, house and holding pens a little farther up the point, and the IOTC cable operator moved into the barracks. The telegrapher was

a friendly fellow named George R. Shultz. Shultz was from Newark, the industrial hub of New Jersey. His relocation to the malarial hell of a southwest Florida wilderness, where he was housed in a crude, unpainted barracks wrapped in the perpetual effluvium of cattle manure, may have dampened Shultz's spirits a bit at first.

However, Shultz's duties as cable station manager at this crossroads of the Gulf, where the paths of so many interesting people converged, was just the right place for a friendly fellow to be. In fact, Fort Myers owes its growth as much to the friendly hospitality of George Shultz as it does to wind, war and its happy cable connection with the wide. wide. world. The forbearance and excellent culinary skills of the woman from Jersey City whom Shultz married in 1873 played no small part; Josephine not only put up with cowboys sleeping in hammocks strung from the floor supports, but she fed the rascals as well—for only a buck fifty a meal.

George Shultz, IOTC station manager and hotel proprietor at Punta Rassa. *Courtesy SWFL Museum of History.*

The Winds of Fortune

To a marvelous degree, the winds of March have been fateful in the history of Punta Rassa and, by extension, of Fort Myers. Running before the wind in a following sea, two of the people who would put the struggling little town of Fort Myers on the map were fairly hand-delivered to George Shultz at Punta Rassa. These storm-driven refugees were a cartoonist and an electrician.

The cartoonist blew in on a blustery day in early March 1881. New York newspaper illustrator Walt McDougall was fishing with friends in the Gulf when a strengthening wind worried them sufficiently to make them seek shelter. With sheets bellying the wind, they headed into the bay and could just make out through waving curtains of rain the wharf and ramshackle barracks of the IOTC relay station. Lashing themselves to the wharf pilings,

Walter Hugh McDougall, the New York City graphic artist and cartoonist who "discovered" Punta Rassa in 1881.

they lumbered through sweeping rain to the barracks. Shultz heard their shouts and laugher and pounding feet in the breezeway, and he threw open his door and welcomed them in.

Shultz and McDougall got along splendidly, especially as McDougall was a native of Newark. In fact, McDougall enjoyed the whiskey-warm hospitality of Punta Rassa so much that he told all his friends up north about it. A good part of the charm of the place, he assured them, were its rustic accommodations. For sports fishing, of course, it had no equal in the world.

Curiously, other sports fishermen cabled Shultz for reservations. The word spread, and soon wealthy businessmen from up north were roughing it in Shultz's old barracks with bare floors and tin washbasins. Besides their primitive living conditions, these gentlemanly sportsmen enjoyed the convenience of keeping up with the stock market and cabling in to their offices via the IOTC telegraph.

Shultz cleverly named his barracks home the Shultz Hotel, and when his guests inquired as to other local places of interest, Shultz invariably pointed them upriver to the up-and-coming little town of Fort Myers.

Thomas Edison, 1895. *Courtesy Edison Muckers.*

The second storm-driven refugee, a disgruntled electrician, arrived in March 1885. Chilling rain had spoiled his vacation in St. Augustine, so he had chased the sun down the Atlantic coast to the Gulf. This fisherman was also from New Jersey and a former telegraph operator, so he and Shultz got along fine. They were relaxing on the veranda one day, their heads wreathed in clouds of cigar smoke, when Shultz mentioned Fort Myers.

"That's where they shipped ole Billy Bowlegs and his people off to Indian Territory," Shultz said.

"Is that so?" Intrigued, Mr. Edison decided to take his yacht up for a look. Upon his return the next day, Thomas Edison informed Shultz that he was thinking about building a winter home in Fort Myers. Shultz undoubtedly chuckled and, clinking the mouth of a whiskey decanter against the rim of Mr. Edison's glass, commented with twinkling eyes, "Now that oughta get us some attention."

With no authorization to do so, but acting on a hunch, a real estate agent in Fort Myers showed Edison a thirteen-acre tract on the river belonging to Jake Summerlin's son, Sam. He was sure, the agent assured Mr. Edison, that he could talk Summerlin into selling. "Make him an offer," Edison said. "Let me know what he says."

The Tarpon

The future can be decided by something as quick as the flick of a mullet's tail.

Scarcely two weeks after Thomas Edison returned to Menlo Park, a sports fisherman from New York, vacationing at the Shultz Hotel, lowered a mullet wired to a hook into the sparkling water of San Carlos Bay. He was not prepared for what happened next. A five-foot, nine-inch tarpon hit with a force that nearly jerked the rod from his hands. The fisherman's rod plunged, and the man locked his chin to his chest and dug in. For the next twenty-six and a half minutes and over a half mile of sea, he battled ninety-three pounds of silver, water-shattering tarpon.

At the time, fishermen believed that a tarpon could not be caught with anything but a shark hook and chain or a harpoon, but on March 12, 1885, W.H. Wood landed one at Punta Rassa with a five-foot bamboo rod. Sportswriters sent illustrated articles to magazines all over the world, igniting a tarpon-fishing craze that washed a rising tide of millionaire tourists in to Punta Rassa. George Shultz merrily renamed his hotel the Tarpon House, and when his guests inquired as to other local places of interest, Shultz invariably sent them upriver to the pretty little town of Fort Myers.

The Oil Man

On a brisk February morning in 1892, a fifty-year-old tourist from Cleveland, Ohio, slopped in his bedroom slippers down the breezeway of the Tarpon House, his housecoat and the ends of its untied belt flapping behind him. Shultz looked up with twinkling eyes as the man was more or less blown into the telegraph room. "Airy out there, ain't it?" Shultz grinned.

"Warm up, though, will it?"

"Oh sure." Schultz shifted his bulk back around in his chair to face the telegraph machine. "Ready when you are."

Rubbing his dry palms together briskly, Mr. McGregor began his dictation, his voice accompanied by the staccato tapping of the telegraph key: "To Mr. J.D. Rockefeller…56 Broadway, New York City… Greetings…"

Ambrose McGregor was one of the major stockholders in Standard Oil and one of John D. Rockefeller's more intimate "mandarin" counselors. His estimated worth at this time was $16 million, with an additional annual income of over $1 million. He was reputed to be one of the ten wealthiest men in the United States. On the advice of their family physician, McGregor and his wife, Jerusha, had brought their ailing son, Bradford, to Florida for the winter.

In conversation with Mr. McGregor, Shultz suggested that if he and his family would like to take a break from sun and sea one day, they might enjoy a trip upriver to a nice little town of some historical interest called Fort Myers.

Upon his return the next day, McGregor informed Shultz that he was thinking about building a winter home in Fort Myers.

McGregor had not ascended to his position with Standard Oil upon sentiment; his decision, therefore, to make Fort Myers his family's winter home may not have rested entirely on the salubrious effect of its climate on his son. With the practiced eye of an investor, he had seen past the frontier rough-and-tumble exterior of Fort Myers to its extraordinary potential. Without hesitation, he purchased the Edisons' guest house and about half their estate for a winter residence and proceeded over the coming years to lubricate the economy of Fort Myers with $150,000 worth of land purchases.

Ambrose McGregor of Standard Oil, "mandarin" counselor to John D. Rockefeller. *Courtesy SWFL Museum of History.*

The Son-in-Law and a Girl Named "Florida"

George and Josephine Shultz had a daughter whom they had named, with charming playfulness, Florida. Florida was a lovely young lady, now in her twenties and engaged to a promising young store owner named Harvie Heitman. Harvie was ambitious, determined, smart as the sting of a buggy whip. His store, on the northwest corner of First and Jackson in Fort Myers, was a fine one, but Harvie intended to grow it, and very possibly in consultation with his future father-in-law, he came up with a singular and forward-thinking way to do just that. He turned his store, in part, into a sporting goods store, stocking it with hunting, camping, boating and fishing supplies. And tobacco products. And liquor.

Now, when guests at the Tarpon House arrived ill- or unequipped for their fishing vacation, George Shultz could recommend a trip upriver to Heitman's, where they could pick up not only rod and tackle but also cigars and a bottle of spirits. Should they wish the use of a conveyance while in town, to sightsee, for instance, out Riverside Drive where the famous electrician Mr. Thomas Edison had his winter home and electrically powered

Heitman's store building today. The original brick is plastered over. *Courtesy Bernard W. Moore, photographer.*

laboratories, Harvie Heitman had a brand-new, handsome livery stable with buggies and sixteen stalls of fine Kentucky thoroughbreds.

Naturally, Florida's daddy wanted to help Harvie out; his little girl's future depended on the young man's success.

It may, therefore, be possible also that when Ambrose McGregor shared with his friend Shultz his interest in building up Fort Myers, say, for instance, with brick instead of wood, Shultz seized the opportunity to mention that his enterprising young son-in-law-to-be could certainly benefit—in fact, the whole town would benefit—from rebuilding Harvie's store in brick. And make no mistake; young Heitman's smart business sense and integrity were such that McGregor could count on a good profit in interest on that loan as sure as he could count on bacon for breakfast.

How ever it came about, in 1897, Ambrose McGregor loaned Harvie Heitman the money to build the first brick building in the ramshackle, wood-frame town of Fort Myers. Harvie would build many more.

The Train

Back in 1886, while Thomas Edison was setting up his laboratory and electric light plant on his riverside estate in Fort Myers, Henry B. Plant was laying his Florida Southern Railway (FSR) tracks to the present-day location of Punta Gorda at Charlotte Harbor, about twenty-five miles north. The arrival of the FSR would do for the Tarpon House at Punta Rassa and, by extension, Fort Myers, what the International Ocean Telegraph Company had done before. Only a short steamship ride away, the railway linked Punta Rassa and, by extension, Fort Myers overland to Tampa.

A new era dawned for the Tarpon House. The Shultzes acquired a staff, including a French chef. With ice deliveries now available, the chef could serve vegetables and fruits, buttery sauces and creamy desserts. Guests included President Grover Cleveland, Scotland's Duke of Sutherland, Zane Grey and Teddy Roosevelt, to name a few. Shultz's first-class guest rooms opened onto a covered promenade that he called, with belly-trembling humor, "Murderers' Row."

The Tycoon

The coming of the railroad to Punta Gorda meant more than an additional means of access to Fort Myers. It brought with it a man who would promote not the Tarpon House but Fort Myers itself as a tourist attraction.

He stepped out of the steam of a panting locomotive at Punta Gorda one bright winter day in 1893. His name was Hugh O'Neill, and he was on a whistle-stop excursion of the Plant System of hotels down Plant's west coast Florida railway line. O'Neill was visiting these hotels because he was furnishing them out of his department store in New York City. The Hugh O'Neill Department Store on Sixth Avenue in New York occupied an entire city block and employed 2,500 people. It was the largest department store in the world.

An immigrant from Ireland at the age of fourteen, O'Neill was an energetic, affable man. As soon as he had concluded his business at the hotel, he caught a steamer down to the Tarpon House to do some fishing. Beaming, pumping George Shultz's hand, he shouted, "And it's tarpon fishing's the thing here now, is it?"

As O'Neill was not the kind of man to relax in the glow of sunset after dinner, Shultz advised him that he might enjoy the rough comradery of the "cow hunters" in the little town of Fort Myers upriver.

"Nice little town," he said, adding with a wink, "still a little rough around the edges, though."

Laughing, O'Neill went and had a fine time, and every winter, he came back to fish and to enjoy "a bit o' sport" with the boys in the saloons and billiard parlors in Fort Myers.

Perhaps, as one winter visit followed another, O'Neill tired of rusticity. Perhaps he simply had hotels on his mind; certainly, it was hotel business that had brought him to Florida's west coast in the first place. In any case, with the capitalist's instinct for opportunity, and after a shrewd appraisal of the town's appetite for development, he had decided by 1897 that with a first-rate hotel, Fort Myers could become the leading winter resort in southwest Florida.

So, he built one—a lavish, exotically landscaped resort hotel on the riverbank just east of downtown Fort Myers (on the approximate site of the expensive army hospital in the old days). Professionally staffed and managed by a famous New England hotelier, it was brilliant with incandescent lights and at the pinnacle of fashion and modernity with porcelain bathtubs and toilets on each floor. Amenities also included a promenade dock for private

Royal Palm Hotel, landscaped with Royal Palms, 1930. *Courtesy Ken Rager.*

yachts and a riverside casino. The grand opening of the Fort Myers Hotel on January 15, 1898, was the most glittering social event in the history of Fort Myers.

Over time, O'Neill landscaped the grounds with exotic tropical trees and flowers, importing from Cuba the first Royal Palms to grace a town that would someday call itself the "City of Palms."

Shrewdly renaming his hotel the Royal Palm, he hired a publicity agent to market the resort in every major newspaper in the Northeast and Midwest. From New York to Boston and Philadelphia to Washington, D.C., diamond-ringed fingers traced steamship routes to a place as exotic and remote to them as Tanganyika.

The rich came to Fort Myers to hunt and fish and were themselves hooked on the leisurely winter lifestyle as well as by the moneymaking potential of this proverbial Florida "paradise." Bending over desks in attorneys' offices, they signed purchase papers for town lots and citrus groves and contracts with construction companies, architects and plantation overseers. One of them, a wealthy Montana cattleman by the name of John T. Murphy, would become a leading citizen of the town, helping to found the First

Left: John T. Murphy, Montana cattleman and builder of the first home (today's Murphy-Burroughs Home) on Millionaires' Row in Fort Myers. *Courtesy SWFL Museum of History.*

Below: Murphy's home today, known more commonly as the Burroughs Home, after its last owner. *Courtesy Bernard W. Moore, photographer.*

National Bank of Fort Myers. He also built, across the street from the Royal Palm Hotel, what the *Fort Myers Press* described in a banner headline as "A PALATIAL RESIDENCE." The three-tiered, seven-thousand-square-foot Georgian Revival masterpiece modeled what Fort Myers could be and would become, as, following Murphy's example, other wealthy businessmen built grand homes eastward along both sides of First Street, a section of town residents would call "Millionaires' Row."

Hugh O'Neill had not only put Fort Myers on the map as a tourist attraction, he had also lit the fuse that ignited the first building boom in the history of Fort Myers.

He had also, incidentally, given Fort Myers its first electric power plant. Fort Myers resident Bertie Gardner had been trying to finance the startup of a power plant for years. When O'Neill announced his plan to build a hotel with its own electricity generator, Gardner approached the big Irishman hopefully. If O'Neill would contract with him for his electricity, it was a guarantee he'd get his franchise and maybe a contract with the town for streetlights and maybe enough other folks would sign up for it, too, and…

Grinning, O'Neill switched his cigar to his left hand and thrust out his right. "Consider it done, then, Bertie!"

The Wife

"Tootie" McGregor, Fort Myers's great benefactress, circa 1910s. *Courtesy SWFL Museum of History.*

Hugh O'Neill and Ambrose McGregor were contemporaries in Fort Myers. Financed by McGregor, Heitman's new store, the first brick building in Fort Myers, opened one month after O'Neill opened his elegant hotel. Perhaps the McGregors invited O'Neill to dinner in their home on the river, and after dinner, in rockers on the veranda, in the slow summer twilight, sipping brandy and puffing cigars, sighing occasionally in quiet contentment, they enjoyed amiable conversation about fishing, the stock market, the future of Fort Myers. If so, Mrs. McGregor was with them, for Jerusha Barber McGregor was not one to retire quietly and leave the men to their business.

Back in '92, when George Shultz suggested to the McGregors a sightseeing trip upriver, he had sent to Fort Myers a tourist who would profoundly alter the landscape of Fort Myers and, in so doing, set in motion a seismic shift in its economic foundation. That tourist was not Ambrose McGregor. It was his wife, Jerusha, or, as she was affectionately called, "Tootie."

The Widow

Ambrose McGregor and Hugh O'Neill died within two years of each other, McGregor in 1900 and O'Neill in 1902. In September 1902, Tootie's son, Bradford, also died. Already suffering from Bright's (kidney) disease, he had not survived surgery for the removal of a kidney stone.

Incredibly, the indomitable Tootie McGregor would return to Fort Myers to finance, in 1905, the construction of Fort Myers's first brick hotel, which she named the Bradford. In 1906, she donated forty acres east of town for the Fort Myers Yacht & Country Club. In 1907, she bought the Royal Palm Hotel from its financially strapped new owner, renovated and enlarged it. Also in 1907, she proposed, and later largely financed, the construction of Fort Myers's first seawall.

In 1912, the town councilmen and county commissioners, with much chair scraping, rose to their feet in the county courthouse once again as Tootie entered the courtroom. More chair scraping as the men sat, a few polite coughs and then silence.

"Gentlemen," Tootie began and then proposed to her astonished listeners the construction of the first hard-surfaced road in Fort Myers. Beginning at Monroe Street on the west end of town, it would follow and overlay Riverside Drive all the way to Whiskey Creek, and if the city and county would pay for that much of it, she would then take this fifty-foot-wide macadam road, at her own expense, all the way to Punta Rassa.

They would, and she did. Her only stipulation was that it be named after her late husband. (Otherwise, it would almost assuredly have been named Thomas A. Edison Boulevard.)

McGregor Boulevard linked Fort Myers and Punta Rassa overland, making wagon, buggy and soon automobile traffic possible between them. McGregor Boulevard would someday effectively reverse the flow of this traffic, from upriver to Fort Myers to down the road to Punta Rassa. McGregor Boulevard may be the greatest civic improvement in the

Left: McGregor Boulevard in 1952 with the picket fence of the Edison Home on the right. *Courtesy Ken Rager.*

Below: Fort Myers's first country club, 1908. *Courtesy SWFL Museum of History.*

history of Fort Myers, for it laid the infrastructure for the building boom of the 1920s. It gave access for construction equipment and workers to the wilderness surrounding Fort Myers, and the city limits began to spread, ultimately to San Carlos Bay on the Gulf of Mexico.

And all this because George Shultz turned an army barracks into a hotel and sent an oil man and his wife, tourists from Cleveland, Ohio, upriver to the up-and-coming little town of Fort Myers.

Fire

The Tarpon House burned to the ground five days after Christmas in 1906. A guest, a descendant of the Dutch Van Horns of New York, was awakened by heat, smoke and the crackling of flames. His shouts put

everyone in the building to flight. Shultz and Josephine, their resident staff and illustrious guests gathered in their nightclothes on the beach and watched with flaming faces as the old building and everything in it, the fishing boats stored under the building, the warehouse and the wharf burned, the molten chunks of its pilings dropping into the fiery water.

Shultz had made a lot of friends who had an awful lot of money. He formed a company with which to solicit the money needed to rebuild the Tarpon House. In January 1908 (while they were breaking ground for the construction of the Fort Myers Yacht & Country Club in the pine woods of east Fort Myers), the splendid new Tarpon House at Punta Rassa was finished. It was a proper hotel this time, two stories of forty waterfront rooms uplifted on pilings, as the old army barracks had been. But now, white muslin, lifted by sea breezes, floated over the windowsills, and a lady in white muslin, lifting a parasol, balanced on fragments of sun-bleached mollusk shells outside. On the downslope of the beach, near the dribbling waterline, a man in a white linen suit framed his lady in the lens of his camera, holding the accordion-pleated box in both hands at waist level, the gold watch chain across his vest flashing fire.

Five years after it opened, with no firefighting equipment available to save it, Shultz's new Tarpon Hotel burned to the ground. The only thing left was the little concrete structure housing the IOTC cable connection with Havana. The urgent tapping along this wire in the late night of February 15, 1898 (one month to the day after the grand opening of the Royal Palm Hotel in Fort Myers), had kept George Shultz hunkered over the telegraph machine all through the long hours of the night, receiving and sending news of the sinking of the USS *Maine* in Havana Harbor and the declaration of war with Spain that followed.

George Shultz died in 1921, at the start of a frenzied building boom that turned Fort Myers into the mecca of sun-seekers that he and Edison

The Tarpon House at Punta Rassa, built by the Shultz Hotel Company, 1908. Notice the steamboats coming downriver from Fort Myers on the distant left. *Courtesy State Archives of Florida.*

Fisherman Berry C. Williams at Punta Rassa fish camp in 1957 with 340-pound goliath grouper. *Author's collection.*

and O'Neill and Tootie McGregor knew it could be. Like a bright color photograph fading to dull sepia, Punta Rassa declined. For the next nearly one hundred years, nothing much happened out there. Commercial fishing families lived in the area, and sports fishermen in Fort Myers drove out McGregor Boulevard to the little Punta Rassa fish camp to bait and ice up, yank the starter cord on their outboards and weave off into the bay. Big whonking ferries churned back and forth, transporting residents and tourists to and from the islands of Sanibel and Captiva until, in 1962, the arching Sanibel bridges and beach- and palm-lined causeways unrolled like a magic carpet to the islands.

In 1982, the sun-bleached bones of the old Summerlin House, where Summerlin used to pay off his drovers in Spanish gold, collapsed.

In 2010, the first condominiums rose to small-aircraft height above the sea. The view from the balconies of these condos is of mangrove and the larger barrier islands, of a mini cruise ship at the dock and sleek, outrageously expensive speed boats slicing shimmering white wakes across the bay. The scene is picture-postcard Florida.

Part IV

Built on Ego

Some say Walter Langford and Harvie Heitman, two of the most dominant figures in the early development of Fort Myers, were rivals. It is said that their rivalry was in no small way responsible for turning Fort Myers from a wood-frame town into a brick city. Others say their enmity retarded the developmental progress of the town.

If enmity there was, we may never know its source. Heitman and Langford were sixteen and fifteen, respectively, when Harvie first came to Fort Myers to clerk in his great-uncle Parker's general store. Like everybody else, Walter undoubtedly observed that Harvie was a serious boy, an unsmiling boy. He was polite but not very friendly. In a small southern town, friendliness is a measure of a person's trustworthiness, so Harvie's lack of overt friendliness puzzled folks a bit, worried them some. But then they reminded themselves that when Harvie was twelve, his daddy, a traveling salesman back in Lexington, North Carolina, had died and the boy had had to take on the responsibilities of manhood very early. He was a good, hardworking boy, after all. No trouble to anybody. Frowns all the time, but that was just concentration on his work. His uncle Howell Parker owned the biggest general store in town, and training up under him, the boy was bound to go far.

Walter Galloway Langford was born in Live Oak, Florida, but his folks had moved to Fort Myers when he was five, so he was one of the first families, you might say. His daddy, Dr. Thomas E. Langford, was a doctor who gave up his medical practice before Walter was born to become a cattleman. Dr. Langford was still a young man when he brought his family to Fort Myers

and went into business with Captain F.A. Hendry's son, James, who wasn't but twenty-four years old himself at the time.

Walter Langford had the early advantage over Harvie Heitman of a college education, and though after graduating from Stetson University he worked cattle for his daddy, he was, with or without effort or merit, the heir of the Langford cattle empire.

Harvie's advantage was that he had none.

Whatever the youthful relationship, if any, between the storekeeper's nephew and the wealthy cattleman's son, in 1906, when Harvie Heitman and Walter Langford sat down together as directors of the Bank of Fort Myers, Walter regarded Harvie with cold eyes.

We may never know why.

We do know, however, that when Heitman was made chairman of the board of directors of the bank, Langford resigned said board. We may safely assume that Langford resented Heitman's foreclosure on the seventy-three thousand acres of land mortgaged to Walter's uncle Nicholas in 1899. The public auction of the property had been humiliating to the Langfords. But whether long-simmering personal animosities underlay these professional maneuvers, again, we cannot know. What matters is that Langford's distrust or dislike of Heitman gave Fort Myers its second bank.

Upon leaving the Bank of Fort Myers, Walter Langford, with friends, organized the Lee County Bank. As soon as the bank received its national charter, it became the First National Bank of Fort Myers.

Langford's First National Bank operated initially out of the Stone Block building on the southwest corner of First Street and Hendry, diagonally across town from Heitman's Bank of Fort Myers on the northwest corner of First and Jackson. Like prizefighters in opposite corners of a boxing ring, the two men slugged it out, figuratively speaking, over who could attract the most customers. The citizen spectators were delighted; both banks were handing out loans like lollipops.

Harvie Heitman, principal builder of downtown Fort Myers. *Courtesy SWFL Museum of History.*

Walter Langford (*right*) in his youth as a cattleman, with Frank Carson. *Courtesy SWFL Museum of History.*

On the other hand, when one bank approved a proposed public improvement, the other opposed it on principle. With the combatants locked in a clinch over every issue, civic improvements in Fort Myers were slow in coming.

One thing in this history is certain: Harvie Earnhardt Heitman was hell-bent on building up Fort Myers with or without the approval of Walter Langford, or of anyone else, for that matter. He was a human sledgehammer. He was a one-man demolition team. He was unstoppable.

Harvie Opens a Store

The panic of 1893 had ruined Harvie's prosperous and popular uncle Parker. Bankruptcy had driven the man Fort Myers had reelected mayor several times over out of town forever. Harvie, too, had disappeared for nearly a year, and then he was back. Back and in business.

He began with a small general store on the northwest corner of First and Jackson Streets. In a town with already half a dozen stores to serve only 751

The telephone exchange on the second floor of Heitman's store, circa 1910s. *Courtesy SWFL Historical Society.*

people, Heitman's was unique in that he stocked boating and fishing supplies to serve the needs of George Shultz's guests in the Tarpon Hotel out at Punta Rassa. Possibly, as young Heitman was engaged to Florida Shultz, the two men had a reciprocal business arrangement.

Over the next ten years, Harvie Heitman became one of Fort Myers's most prosperous citizens. By 1900, his new brick general store, painted green with gold trim, was the premier retail establishment in southwest Florida. Its construction financed by none other than Standard Oil tycoon and Rockefeller associate Ambrose McGregor, Heitman's was the first brick building in town. It grew to include a bakery, turning out freshly baked breads and desserts daily; a grocery, with *refrigerated butter and cheese*; sporting goods; tobacco; and liquor.

Heitman also achieved fortune and notoriety with his fine livery stable, whose sixteen stalls housed Kentucky thoroughbreds for hire as saddle and carriage horses. Trading in livestock, running a hack line to Naples, acting as agent and manager for the local business interests of Montana cattleman Dan Floweree and Thomas Edison, he was a busy man in the affairs of the town. Like Fort Myers's first telephone exchange, which occupied the second floor of his store, the business of Fort Myers seemed to flow circularly through Harvie Heitman.

Harvie Builds a Bank

When the Citizens Bank & Trust Company of Tampa was persuaded, principally by James E. Hendry, to open a branch in Fort Myers in 1901, Harvie Heitman evicted the tenants in the wood-frame building next to his store, tore the thing down and built a brick bank with a plate-glass front. He installed a vault lined with Bessemer steel and secured with automatic locking devices. The interior of the bank was finished in black cypress and, in keeping with the technological advances of the new twentieth century, furnished with running water, electric lights and telephones. The grand opening was staged with the expected Heitman fanfare and attended by local and Citizens Bank dignitaries. Mr. James E. Hendry made the first (quite large) deposit; the total dollar amount of deposits that day exceeded those made at the home branch in Tampa.

Thus, by 1901, Heitman owned the biggest retail business in Fort Myers and housed both the telephone company and the only bank in town. Even

Harvie Heitman's store, circa 1920s.

the fire of '03 that almost reduced Fort Myers to ashes and swept away his livery stables didn't faze him; he had his fingers in too many pies.

Heitman was, perhaps by genetic inheritance, a consummate salesman. The *Fort Myers Press* was filled with ads for his businesses; he marketed his merchandise with saucy, rhyming hyperbole. His bakery was "mammoth"; his selection of merchandise at Christmas "surpasses many of the larger New York and Philadelphia stores." He innovated in his advertising by using the first commercially successful comic strip character, the "Yellow Kid," as his mouthpiece. He hired the first store Santa Claus and used balloon ascensions at night, with fireworks, to bring Christmas shoppers to his store. Heitman's Christmas window display was the Macy's of Fort Myers.

Heitman gave Fort Myers many of its "firsts." In addition to the afore-described bank, he laid the first sidewalk in Fort Myers; it led from the river at the Jackson Street dock straight up Jackson Street to his store. At his own expense, he laid the underground wire for the first electric streetlights in Fort Myers; they fronted First Street from Hendry to Jackson, the section referred to as the "Heitman block."

Langford Gets the Railroad

A man like Heitman either attracts or repels; the intensity of the man excites either admiration or suspicion. In Fort Myers, the townspeople lined up with or against him. The Langford faction could, with apparent justification, say that, sure, Heitman was bringing improvements to the town, but they were calculated to serve his own interests, whereas Walter Langford, now, had given Fort Myers its first nationally chartered bank, and before that, by God, he'd brought us the railroad. Nothing was less calculated to one man's self-interest than that. Nothing on earth could compare with the godsend of the railroad to a town that had been isolated from the rest of the world, in every practical sense, since Manuel González stepped off the boat in '66.

Beginning back in 1902, young (thirty-year-old) Langford had begun writing letters to the great Atlantic Coast Line (ACL) Railroad, stating the need of Fort Myers for a railroad. He built up the potential of the town for prosperous growth to the point that they finally sent a man down to talk. Well, the man was treated like the emperor of the world for the time he was in town, and sure enough, he persuaded headquarters that they ought to run track into Fort Myers. When the word got out, people went wild.

The first thing they did was organize a board of trade to buy up the land needed for the right of way and a train depot. And who was on the board of directors? Harvie Heitman. And who was not? Walter Langford.

Be that as it may, the railroad was Walter Langford's legacy. With the railroad came new industry, including commercial fishing and agriculture and produce packing. Now citrus growers and vegetable farmers and fishermen could get their goods to market. Now tourists, new residents and investors bringing new business could come in overland. And when it came to talking new business into Fort Myers, Walter Langford was hands down the winner.

Harvie's Fairy Godmother

In the same winter (of 1904) that Mrs. James E. Hendry drove the last spike in the ACL railroad track in Fort Myers, Mrs. Ambrose "Tootie" McGregor returned. Widowed in 1900, she had lost her son, Bradford, two years later, but now she was back and with a lot of money to spend.

Dinner with the Heitmans was her first social engagement of the season, of course. Tootie was fond of the couple whom she and her husband had befriended back in '97, when George Shultz introduced his daughter, Florida, and her fiancé to the McGregors. Harvie and Bradford McGregor had been the same age, and now Bradford's grieving mother may have regarded Harvie with a certain wistful fondness, perhaps seeing in him the man her son might have become. In any case, she was more than fond. She knew Harvie had what it took to become as solid a success in Fort Myers as her husband had been in the larger world of Standard Oil. Like her husband, he'd come to his position through intelligence, hard work and indefatigable energy. In other words, she trusted him absolutely with her money.

Her trust was not misplaced.

The McGregor-Heitman financial alliance had continued in the years since they first met. For instance, when Bradford died in 1902, Tootie sold her winter home on the Edison estate to Harvie, who purchased it only to leverage a deal with the owner of a historic house in town that stood conveniently across Jackson Street from his store. Since their marriage, Harvie and Florida had been living in a house in town owned by Florida's father, George Shultz. But the house Harvie wanted was the one at First and Jackson once owned by Mr. James E. Hendry, Dr. Langford's old partner.

The location was prime; from his front veranda, Harvie could look directly into the main street of the town he was building. So, he traded the McGregor house on Thomas Edison's estate for the Hendry house.

A half century earlier, during the Indian wars, the house had been the fort's commanding officer's quarters. The irony of the fact that the house was now home and headquarters to the man who would direct the building of a new city on the fort site was not apparent at the time. Nor would it be realized, except through hindsight, that the only reason the oldest and most historically significant building in Fort Myers survived Harvie Heitman was that he was living in it when he brought the rest of old Fort Myers down around everybody's ears.

Harvie Builds a Hotel

We do not know whether Harvey came to Tootie or she summoned him, but in the winter of 1904, they made plans to build a hotel. It would be the first brick hotel and the first three-story brick building in Fort Myers. Harvie

The Bradford Hotel block today. *Courtesy Bernard W. Moore, photographer.*

cleared the lot on the northeast corner of First and Hendry for it, tearing down a wood-frame building then housing a small cigar "factory" and Fort Myers's first public reading room, and, to the dismay of many, cutting down an aged and prolific pecan tree and half a dozen heavily laden orange trees.

The construction of Tootie's massive, forty-three-room Bradford Hotel required 100,000 Chattanooga pressed bricks. Its rounded corner entrance, arched window and door frames and ten-foot-wide, second-level veranda, along with the plate-glass windows across the retail spaces on the ground level, made the hotel very grand and modern in appearance; its steam heat, electric lights, private baths and carpeted hallways and sitting rooms made it world class.

Its restaurant and Tabard Inn library, a revolving wooden bookcase for nickel books, were favorites of the townspeople, as well. And when the hotel organized a gun club, the Bradford became a favorite for visiting hunters, who tied their hounds and bird dogs to the doorknobs outside their rooms at night.

At the grand opening of the Bradford Hotel in November 1905, the first names on the guest register were in the hand of George Shultz and his son-in-law, Harvie Heitman, the men signing also for their wives.

Tootie's Silent Partner?

Rumor has it that in 1907, when Tootie bought the Royal Palm Hotel from its insolvent owner, she did so at the urging of Harvie Heitman. If urge her he did, she was easily persuaded. In fact, she seemed to look upon her investment with some amusement. She sent a teasing telegram to her friend Henry Flagler, co-founder with J.D. Rockefeller of Standard Oil, and Florida's east coast railway and hotel mogul. "I have bought a small hotel on the west coast." His reply was instant: "Another one in the family gone wrong."

A few months later, Tootie slyly poked her old friend again: "My hotel has made money."

Having made the Royal Palm Hotel her winter home, Tootie and her second husband, eminent New York physician Dr. Marshall Orlando Terry, decided to do something about the condition of its waterfront. It stank. It was a sewage and garbage dump. Cows wandered knee deep in it. Swine rooted around in the muddy shallows.

In 1908, Tootie and Dr. Terry proposed a public hearing on the matter. Money and prestige command attention everywhere; when the Terrys stood up in the county courthouse to propose the construction of a seawall and a landscaped promenade along the waterfront of Fort Myers, the room was packed with interested citizens.

Everybody loved the idea, but true to form, nobody wanted to pay for it, and on second thought, neither the private nor the business owners of waterfront property liked the idea of a public walkway separating their properties from the river. Like so many proposals for civic improvements, the seawall idea was set aside for a while.

Ultimately, however, certain persons favoring the project prevailed, and a waterfront association was formed. Not surprisingly, Harvie Heitman was made its treasurer. In the end, Heitman and Tootie shouldered the greater portion of the construction costs, with other waterfront property owners, including Walter Langford, contributing their proportionate share, and in 1908, Fort Myers got its first seawall.

In the same year, Fort Myers's first yacht and country club opened on land donated by Tootie McGregor, with Harvie Heitman as vice president. Walter Langford was not among the club members.

Harvie Crosses First Street

The year 1908 was also when Heitman initiated his takeover of the south side of First Street.

Edward Evans, former mayor, friend to Thomas Edison and tarpon fishing enthusiast, managed a sporting goods store on the southeast corner of First and Hendry, directly across the street from the Bradford Hotel. Evans, who designed fishing tackle for fishing tackle manufacturers, was persuaded by Heitman to join him in the creation of the Heitman-Evans Company, with Evans as manager and Heitman as silent partner. They opened a hardware and sporting goods store, which Harvie promoted in true Heitman fashion by placing a tarpon fishermen's scoreboard in the front window during the winter tarpon season. As in the past, Harvie and his father-in-law, George Shultz, were undoubtedly practicing a bit of cross-promotion between the sporting goods store and the Tarpon House out at Punta Rassa.

Harvie Builds a Packing Plant

As the first decade of the twentieth century gained momentum, so did Harvie Heitman. In 1909, with Heitman as president, the Lee County Packing Company was formed; it gave Fort Myers its first modern packing plant. Two stories high and 130 by 250 feet, the plant required the construction of its own wharf at the end of Hendry Street. The project cost a quarter of a million dollars and would produce the largest citrus-packing plant in the world. Its seventy-five employees, operating mechanized equipment under electric lights, turned out twenty boxcar loads of fruit a day.

Hardworking grove owners upriver protested the advantage that a corporation based in Fort Myers and empowered to wheel and deal in the interests of its shareholders and absentee grove owners would have over the farmers in the fields. This objection was raised by a Mr. Parkinson of the small community of Alva upriver. English-born Edward Parkinson was prominent in the citrus industry and in county and city affairs; he was also a friend of Walter Langford, having joined him in forming the Lee County Bank in 1906. But Heitman and his partners were not to be derailed; in their rush to growth and prosperity for Fort Myers, and for themselves, of course, Parkinson's eloquent appeal for a more equitable means of growing the citrus industry was ignored.

In this 1925 aerial photo, the railroad tracks curve to the Lee County Packing Company plant on the river (*right*). *Courtesy SWFL Museum of History.*

With the sudden influx of citrus and seafood brokers, of land buyers and developers and tourists, the Bradford Hotel was operating to capacity in season. So, in 1910, by adding a seamless annex, Heitman doubled the size of the hotel. In the process, he demolished the second oldest structure in Fort Myers, a house that had been original to the fort. Again, the *Press*, though generally supportive of Heitman's work in rebuilding and modernizing Fort Myers, sadly noted the loss of this historic house.

Harvie Builds a New Bank

In 1911, Heitman built the three-story brick Bank of Fort Myers, opposite its former location on the north side of First Street next to his superstore. The *Press* described it as an "ornament" to the city, and indeed it was, with its stylish hip roof, decorative white-brick designs and thick white pillars supporting great arched entryways.

Coincidentally perhaps, Walter Langford's uncle Taff Langford, beloved Fort Myers saloonkeeper, pulled down the wooden structure next to the bank and constructed his own two-story brick building, which provided

The former Bank of Fort Myers building today. *Courtesy Bernard W. Moore, photographer.*

The Langford building today. *Courtesy Bernard W. Moore, photographer.*

First Street looking west, circa 1912. Note the street ad for the Grand (*lower left*). *Courtesy Tim Hennigan.*

space on the top floor for the Grand, Fort Myers's first motion picture theater. Flickers were shown daily.

Little now remained of the original Fort Myers, the frontier town where cowboys rode the merry-go-round back of Frank Carson's livery stable, going around and round, whooping and hollering long after the saloons closed and the saloonkeepers dropped wearily into their beds. Cars puttered down the streets now, and in the darkened Grand Theater, faces lifted expectantly to the pulsing light and shadow of make-believe.

Walter Builds a New Bank

In 1913, First National Bank president Walter Langford contracted for the construction of a First National Bank building on the corner of First and Hendry, on the site of the Heitman-Evans store. (Heitman was moving across the street.) The monument to pseudo–Greek Revivalism was finished in August 1914. Like a Greek temple, in white-hot summer sunlight it reared Ionic columns to a triangular tympanum, its twin entrance doors opening to a sanctuary of cold white marble.

It was Walter Langford hauteur in solid granite.

Harvie Demolishes the South Side of First Street

As Langford's $50,000 bank was rising, block by granite block, Harvie knocked down the historic old Jehu Blount general store on the northwest corner of First and Hendry and began work on a new two-story Heitman-Evans store with hardware on the first level and agricultural implements on the second. To add to the list of Heitman "firsts" in Fort Myers, his new building was equipped with a water sprinkling system. As if for good measure, he also threw up a $10,000 roller-skating rink back of the Bradford on Bay Street.

Now he turned back to the south side of First Street, where the cold gray granite of the First National Bank building continued its monumental ascension. Jerking down every old wood-frame building between Taff Langford's building on the east end of the block and Walter Langford's bank on the west end, he began construction of an $85,000, 193-foot-long, two-story building that he called the Earnhardt.

Six months later, the Earnhardt was finished. It was Harvie Earnhardt Heitman's masterpiece. Creamy brick, ornamented with decorative cornices and white and green trimming, it offered eight retail spaces on the ground floor and thirty-five office spaces on the second. It also boasted Fort Myers's first public washroom, complete with hot and cold running water.

The Jehu Blount store at First and Hendry, circa 1880s. Courtesy SWFL Museum of History.

Above: The Heitman building today. *Courtesy Bernard W. Moore, photographer.*

Left: The First National Bank building today, adjoining Earnhardt building. *Courtesy State Archives of Florida.*

In the process of all this tearing down and building up, the town council exempted Heitman from any permitting requirements. They were grateful to him for removing "these old, unsightly buildings from the principal street" and erecting in their place modern brick structures that gave Fort Myers "an air of progressiveness." Foremost in the minds of Fort Myers citizens was the wish to impress visitors with the modernity of the city. When two members of the city building committee objected to Heitman's moving buildings (preparatory to demolition) without a permit, the mayor excused Heitman from any fines. The mayor did not feel that a man engaged in building up and improving Fort Myers should be "hampered by these little technicalities."

Coincidentally, perhaps, with this mayoral decision, Heitman had workmen renovating the city council chamber, giving it robin's egg blue walls with a cream ceiling and woodwork stained in "mission tones."

Permit or no permit, Harvie Heitman was not about to be slowed down; he didn't have time to go to court, he said. He'd rather just pay the fines and proceed with his business.

Nevertheless, council members argued whether to approve his multiple building plans, including those for a combined municipal market, fire department and city hall. His plan called for screened stalls for the market, which, in addition to meats and vegetables, would include a bakery and dairy. To ensure the proper sanitation, he proposed that the council appoint a sanitary inspector. The objections raised on one point or another seemed niggling, however, compared to the obvious advantages in acquiescence, and the building plans were approved.

The original wood-frame buildings that had composed nineteenth-century Fort Myers were not standing vacant when Heitman decided to raze them. The tenants of these buildings were notified of the intent to demolish their places of business, and they relocated, if they could. One of the town's old buildings came down, however, despite Harvie Heitman's strenuous objections and all his legal (and backroom) maneuvers to stop it.

A Standoff

The Heitman and Langford factions came to a standoff over the question of building a new county courthouse. Heitman's friends would have explained the impasse along the lines of:

For nearly twenty damn years, "Bulldog" Bill Towles, a Langford crony, has been dead set on building a new courthouse. He's never let up on the idea. So back in October of '14, with everything else going on, including the great war in Europe, he wants taxpayers to cough up $100,000 for this damned high-falutin' courthouse that nobody needed except Mr. County Commissioner Towles wants himself a new office and a grand courtroom. And indoor toilets, mind you.

Bill Towles, speaking for Walter Langford, may have reasoned thus:

Heitman may have built the first brick building in town, but with McGregor money, which ought to have been used to build Fort Myers a solid stone courthouse instead of Harvie Heitman a store. Then when McGregor dies, Heitman prances over to the man's widow and asks for money to build a hotel. So, next we have a forty-one-room, solid

concrete Bradford Hotel while the county commissioners are still meeting in a creaky old courthouse that don't even have toilets. And now, when we have finally got a new courthouse approved, Heitman wants to fight us on it. Half the town's being torn down for the Heitman buildings, yet he don't think it makes any sense to tear down this old fire hazard of a courthouse because, according to Harvie Heitman, it's still in good shape.

The board of Lee County commissioners, chaired by Towles, contracted with architects three times to build Towles's dream courthouse. Twice the anti-courthouse faction, headed by Heitman, brought injunctions from Judge Whitney in Arcadia to stop them on technicalities; the third time, the architect was persuaded to abandon the project. When Bulldog Bill rehired his first architect, Heitman's emissaries boarded, yet again, the next day's train to Arcadia. But this time, even as the locomotive was huffing out of the station on Monroe Street, Towles's demolition crew was rounding the corner on Second and Jackson with hammers and crowbars.

They set to work on that old courthouse and brought it down overnight. They built a bonfire of the wood to light them through the darkness while Towles sat guard with a shotgun across his lap to warn off any protestors.

Heitman did not meet the train when it returned from Arcadia the next morning. Sitting in his second-floor office in the Bank of Fort Myers before a cold hearth, lock-jawed with rage, he waited for his accomplices to come to him. Stepping off the train and crossing the tracks on their way to the

Lee County Courthouse, built in 1915, today. *Courtesy Bernard W. Moore, photographer.*

bank, new injunction in hand, they stopped and stared at the empty lot where, twenty-four hours earlier, the courthouse had stood. It took them long seconds to fully comprehend that it was just not there. There was a very big pile of siding and the smoking embers of a fire and nothing else but sky.

In December 1915, the new courthouse was finished. It stood there in all its solid yellow brick and granite, neoclassic, insolent grandeur, its broad granite steps ascending proudly to a porch fronted with towering Doric columns, its great double doors opening to an immense lobby of marble and darkly gleaming wood.

It was Walter Galloway Langford to a T.

Harvie Demolishes the North Side of First Street

Now Harvie Heitman was moving like a whirling dervish down the north side of First Street, all the wood-frame buildings between the Bradford on the west end of the block and his store on the east end clattering down in his wake. Dividing the block with a centered, tiled arcade running the width of the block from First to Bay Street on the river, he built retail space opening

Heitman's Arcade, Bay Street entrance, 1935. *Courtesy State Archives of Florida.*

First Street Arcade, 2016. *Courtesy Bernard W. Moore, photographer.*

along either side of the arcade and, on the river side, Fort Myers's first bona fide theater.

Previously, flickers had been shown in the Grand, which was nothing more than rented space in Uncle Taff's building next to Harvie's bank, and live theater performances had been staged in rented space above the old Heitman-Evans hardware store, but now Fort Myers had a real theater with a stage for live plays and vaudeville acts, magic and local talent shows, with comfortable, built-in seats *and* a moving picture screen.

Two years later, Harvie updated his Arcade Theater with lamps and fans mounted on walnut walls, four hundred veneered seats, a spacious stage with footlights and dressing rooms and lights hanging from a steel ceiling. This sumptuous new theater opened on February 25, 1917, to a full house.

New Life

After a decade of remodeling and updating itself, Fort Myers was now poised, like a youth newly and fashionably suited, with slicked-back hair and shining shoes, to enter a new era in its life.

To fulfill his destiny, the youth must leave behind the parents who have raised and groomed him. He stands with lifted chin and eager eyes as his parents fuss over him, giving a last jerk to the knot in the tie, a last pat to the shirt front, picking a piece of lint off his lapel and then smoothing, caressing the fabric until, with a last searching and hopeful gaze into his eyes, they must let him go.

And thus, on the eve of the Florida building boom of the 1920s—a real estate, construction and population expansion of inconceivable magnitude—Harvie Heitman and Walter Langford retired from their labors and died, Walter in 1920 at the age of forty-seven and Harvie two years later at the age of fifty.

Their work was finished. They, with others of their generation, had given Fort Myers sturdy bones and good teeth, a whetted appetite for growth and muscles flexed for new development, and even as they receded into the pages of their own history, Fort Myers rushed into the future. In the decade to come, the old, frontier Fort Myers, like a face wavering beneath water, would sink wholly from sight and memory, and the outlines of a new city would emerge. As fast as the pistons and wheels of machines can turn, Fort Myers would continue to grow east to west and north to south, following the sweep of the flowing river all the way to the Gulf of Mexico.

Part V

The Sometimes Creative Effect of Dynamite

Depending on the length of the fuse, dynamite can take a while to ignite, but the explosion is spectacular. It is followed by a heavy rain of debris, dribbling to pebble-fall, and the show is over. And yet, as the cloud of dust clears, something new emerges. Setting off dynamite can be an act of creation as well as one of destruction.

Between World War I and World War II, the population of Fort Myers nearly doubled. This remarkable growth is attributed, correctly, to the Florida real estate boom of the 1920s. What few people realize, however, is that the fuse that lit the boom was slow to reach Fort Myers. It was not until 1925 that the dynamite ignited. The explosion was spectacular, but quickly over. It lasted only one year.

The Fuse Fizzles

In the general prosperity following World War I, Florida was flooded with tourists. Many came by rail, others in their own automobiles and trucks. The "tin can tourists" came with improvised trailers in tow or driving "house cars," an early version of the RV. But the motorists got only as far as Sarasota before they ran out of road. Even the more adventurous who set off down the deep sand and mud trails into the wilds of southwest Florida came to a halt at the Caloosahatchee River. They could see Fort Myers across the

Richards Royal Palm Pharmacy, Fort Myers, 1920s. The tall, slender man on the right is Connie Mack.

shining water, but the only way to get to it was to have the car poled across on a ferry. For Pete's sake, why bother? So while the rest of the state was filling to the brim, like a flute of champagne, with tourists, new residents and investors, the multimillion-dollar Florida real estate boom was, for the residents of Fort Myers, like a distant babble of voices coming from a party across the river. The fuse that might have ignited the dynamite fizzled out in the water on the north side.

Like a match, a decade-long debate over road building was struck again and again. The question was no longer whether to build, but when and where. If they could just get the dang thing lit.

The Tamiami Trail

In 1915, the Florida legislature created the Florida State Road Department and approved funding to build roads. The proposal to build a highway linking Tampa with Miami was accepted and the road cleverly named the Tamiami Trail.

Tamiami Trail boosters. *Courtesy State Archives of Florida.*

It may be remembered that it was largely through the efforts of Walter Langford that, in 1904, Fort Myers had linked itself to the rest of the nation with the Atlantic Coast Line Railroad. Langford died in 1920, but not before he completed the work of paving the way to Fort Myers for tourists and future investors by securing from the landowners in District Three of the Lee County Road and Bridge District the rights of way necessary to bring the "Trail," the biggest road-building project in the history of Florida, through Fort Myers.

Lee County recognized that without paved roads, its economy would stagnate like muddy water in wagon ruts, but it was forever slow and contentious in paying for them. Only when the Chevelier Corporation, with interest in the agricultural development of the Everglades (principally for sugar production), and, later, Barron Collier contributed heavily to the project in exchange for certain considerations did the match flame to the fuse. In the spring of 1925—IGNITION—the Tamiami Trail met the Caloosahatchee River at Freemont Street in east Fort Myers.

The Explosion

In March 1925, the first automobile to do so rolled onto a new one-lane wooden bridge at the end of Fremont Street and drove across the Caloosahatchee River.

Then it was "Katie, bar the door!" for the party had come to Fort Myers. In the moneymaking and spending frenzy that followed, the population

increased six times over and the city limits expanded to eight times their previous size. Fort Myers's banks were bulging with money. Bond issues for public improvements flew out of city hall like flocks of birds. Deliriously, citizens voted for improvements to the water system and fire protection service, for sewer extensions, street paving and gas mains. New buildings shot up past the former roofline of the town, and new schools and houses, apartments and tourist courts, churches and gas stations popped up all over the spreading city. By 1925, the total in building permits neared $3 million. In the same year, as if in celebration of its highway link to the rest of the United States, Fort Myers built itself a new Atlantic Coast Line Railroad station. The splendidly white building with its rounded arch doorways and windows and red tile roof was, like whole subdivisions of new houses, built in Spanish Mission style, the latest craze in architecture. The first passenger train to roll in was met with much cymbal clashing by the Fort Myers Concert Band and the cheering of over three thousand people.

However, inbound freight trains were bottlenecking at northern railway junctions, so the railroads imposed an embargo on freight shipments to Florida. No problem. Fort Myers shipped building supplies in the old-fashioned way—by ship.

Sideshows and Entertainments

In hindsight, Fort Myers seemed to have taken on a carnival atmosphere, and one of its premier attractions was the Edison, Ford and Firestone show. Since 1885, citizens had boasted of having the world-famous inventor Thomas A. Edison in winter residence, and since 1916, Mr. Henry Ford, himself, inventor of the Model T motor car and millionaire head of the great Ford Motor Company, also had his winter residence on Edison's estate out on McGregor Boulevard.

Yessiree. Mr. Edison and Mr. Ford were great friends, going back to 1893, when Ford was made chief engineer of the Edison Illuminating Company in Detroit. It was while in Edison's employ that Ford invented the gasoline-powered four-wheel vehicle that was the daddy of the Model T.

Everybody remembered the day the train pulled into the ACL station on Monroe Street with two shiny-new Ford sedans aboard—one for Mr. Ford and the other a gift for his former employer and old friend Thomas Edison. Everybody in town with a car was there to meet the train, and when

Henry Ford, Thomas Edison and Harvey Firestone, 1923.

the sedans rolled off it and the drivers got in them and started off for the Edisons' place, all the motor cars in town fell into line behind them and made a regular parade out McGregor Boulevard.

It turned out that Ford and Edison were in cahoots over rubber. Edison had been trying to figure out what kind of plant or tree could be used to make a substitute for rubber, and naturally, Ford was interested. As was Mr. Harvey Firestone, who started out making rubber tires for buggies and now was the millionaire owner of the Firestone Tire and Rubber Company. You can bet he was interested. Ford's and Firestone's fortunes rode on rubber, you might say, so the three of 'em—Edison, Ford and Firestone—were thick as thieves. They were a threesome under more front-page headlines than a body could count.

Falling Debris

January 1926 was cold, windy and grey. Real estate values began to drop a bit. Generally, people didn't pay too much attention. The killer hurricane that struck on September 18, 1926, therefore, was like a cold slap in the face.

Hidden History of Fort Myers

Right: James E. Hendry Jr. in his Everglades nursery, Fort Myers. *Courtesy SWFL Museum of History.*

Below: James Hendry Jr. (with his wife, Florence) receives the Johnny Appleseed Award for planting the trees that made Fort Myers the City of Palms. *Courtesy SWFL Museum of History.*

One-hundred-mile-per-hour winds swept over Punta Rassa, killing two. A storm surge of six feet flooded streets, houses and automobiles. When the water subsided, it took the real estate carnival barkers with it, along with construction workers and administrative personnel in sales and other upstart business offices, leaving the citizens of Fort Myers picking up the litter of their town, their homes, their shattered fortunes. The party was over.

But city commissioners, if not always reasonable, were almighty stubborn, and they continued work on the $128,000 city pier, auditorium and swimming pavilion at Evans Park; welcomed the Seaboard Air Line Railway and its president with a big celebration attended by the governor of Florida and hundreds of SAL guests; and in '27, purchased the privately owned Fort Myers Golf & Country Club on McGregor Boulevard, because how can you sell yourself as a resort city without a golf course? In 1928, they undertook the largest street beautification project in southwest Florida history by contracting with James E. Hendry Jr. (the grandson of Captain F.A. Hendry) to plant nearly seven thousand trees along thirty-seven miles of city streets, because how can you sell yourself as a Florida paradise without palm trees?

Pebble-Fall

In October 1929, like the last whoosh of earth and stone after an explosion, the bottom fell out of the stock market. In Lee County and Fort Myers, prices for everything from cattle to crops plummeted. The Bank of Fort Myers, the Lee County and the First National Banks closed, the Bank of Fort Myers permanently. By 1933, one-third of county resident workers were unemployed. Tax revenues sifted into airborne dust.

A New City Emerges

Like the aftermath of an explosion, the collapse of the stock market cloaked the nation in the dark cloud of the Great Depression, but when the sky cleared, a new Fort Myers was revealed.

At the river's edge of Fowler Street, between the old Royal Palm Hotel and John T. Murphy's home (now occupied by two old-lady sisters named

The Edison Bridge across the Caloosahatchee, 1940s. Courtesy State Archives of Florida.

"Burroughs"), a new two-lane concrete bridge shot straight as an arrow across the river. After decades of wrangling between the city's fiscally conservative and progressive factions, the city had chosen 1931, a year of acute financial crisis, to add this critically needed and long overdue missing link to its infrastructure. The necessity of putting its unemployed men to work had achieved what no amount of argument had ever been able to do. Thomas Edison himself dedicated the Thomas A. Edison Memorial Bridge on his eighty-fourth birthday; it was his last public function in the "up-and-coming little town" that he had discovered in 1885, for the old man died six months later.

In 1932, Fort Myers received a $200,000 grant from the federal government to build a post office. Having the equivalent of nearly $4 million in today's U.S. currency, they built a very nice post office. With thousands of tons of indestructible white Florida keystone and 159 tons of structural steel, they raised the most magnificent building in Fort Myers history—a twenty-three-thousand-square-foot, neoclassic revival facsimile of the Parthenon, its six massive ionic columns ascending to neck-breaking height.

Walter Langford would have loved it, especially the 160-foot secret tunnel, painted black, around the ground floor, which allowed the U.S. postal inspector to observe through three-sixteenth-of-an-inch slits the cashiers at work.

In late 1933, when federal works projects money began to arrive, a maturing, more sober Fort Myers put the money into infrastructure: streets were repaired or reconstructed and sidewalks laid; sewers were repaired and a new water plant built. WPA money repaired schools and initiated school lunch programs, and it replaced the old fifteen-bed, wood-frame hospital with a new fifty-five-bed facility with surgery and emergency operating rooms, an X-ray room and a maternity ward.

HIDDEN HISTORY OF FORT MYERS

The post office, Fort Myers, 1930s. *Courtesy State Archives of Florida.*

 Motivated, as always, by its desire to attract and accommodate tourists, and thirty years after rejecting a similar proposal by Tootie McGregor, Fort Myers turned the riverfront of downtown into a beautiful yacht basin and waterfront park complete with shuffleboard courts. And incredibly, only a few years after finally providing a bridge for tourists arriving by car and a harbor for tourists arriving by water, Fort Myers opened a…sort of…airport.
 As early as 1924, the chamber of commerce had been in conversation with federal aviation authorities about the creation of an airfield for receiving mail service. In the wide-eyed optimism of 1925, the chamber also initiated talks with the Florida Airways Corporation (FAC) regarding passenger, as well as mail, service to Fort Myers. The FAC assured the city that if it would give the requisite acres, the FAC would build the airfield and hangars. The *Fort Myers Press* urged acceptance of the offer, proclaiming that by thus providing fast and easy access to the west coast, millions of people and dollars would flow into Fort Myers from Miami. To a city that had yet to bridge its own river, the idea may have seemed a bit lofty. In any case, the airport idea got lost in the rapid shuffle of city projects that year, and nothing came of the talks.
 Once planted, however, the idea of an airport took root with the ferocity of Bermuda grass, and in 1927, Fort Myers began clearing acreage, previously intended for a municipal golf course, for use as an airfield.
 It was only a grassy L-shaped field in a subdivision four miles south of town along the Tamiami Trail, but the city hoped that it put a bull's eye on Fort Myers for airborne tourists. And, in fact, in 1937, National Airlines added a mail and passenger stop at the little airfield in its Tampa-to-Miami schedule. In the rainy months, however, the field was so muddy that the airline often had to cancel flights, and after only a few months, National cancelled the service.
 Urgently, then, in 1940, Fort Myers obtained WPA help in building concrete runways at the now Lee County Airport. The first three-thousand-

foot-long runway was underway when a *Fort Myers News-Press* story that year proclaimed that the "airport is likely to be the most important factor in this city's future prosperity and we shouldn't waste a minute's time putting it into service."

Anticipating revenues from pilot-training programs and passenger and airmail service with national airlines, Lee County planned to acquire an additional two hundred acres, with hangars and an administration building. The Civil Aeronautics Administration (CAA) already operated a weather radio station at the airfield, and twelve private planes were parked there. Tourists, including sport fishermen, were not only floating into Fort Myers now on water; they were also floating in on air, some on private and some on chartered planes.

Commercial aviation in Fort Myers was about to be put on hold for a little while, however. By the end of 1940, the U.S. Army was looking at the airport.

Part VI

A Lost Page in Fort Myers History

It is not well known how ardently Fort Myers city boosters wanted the U.S. Army to take over (and complete the work of building) the Lee County Airport, nor how hard they worked to that effect. The county commissioners, the mayor and city council grew impatient with the gradual progress made by the WPA workers in building a proper runway. An army officer from McDill Field in Tampa, speaking at a Rotary Club luncheon in June, had assured club members that as soon as the runways were sufficiently extended and hard-surfaced to accommodate big bombers, the Lee County Airport could expect plenty of fly-ins from Florida air bases. Later that month, a Civil Aeronautics Administration official, accompanied by army aviation officials from McDill, flew in to inspect the progress made on the airfield. Rumor had it that the army would procure federal funding to ready the field for use as a bomber squadron base. Army officials had told Lee County commissioners and the mayor that south Florida was vital in protecting U.S. interests in South America, particularly the Panama Canal. The city and county eagerly awaited confirmation of the army's intent to make Fort Myers part of its defense plan.

Bumping Along

In the meantime, Fort Myers used the raw little Lee County Airport as a sort of fairground. The Flying Pelicans aviator club sponsored a model

airplane competition out there, in which boys competed for distance and flight duration, fueling their model planes with gasoline from an eyedropper. The police sponsored air shows with stunt flying and parachute jumps and flour-sack bombings of airfield targets.

During the tourist season, Carl Dunn, operating the Fort Myers Air Service out of the field, airdropped five hundred copies of the *Fort Myers News-Press* to resorts on Bokeelia, Sanibel, Captiva, Useppa and Boca Grande islands, making a special low-altitude delivery to Harry Stringfellow, the chairman of the Lee County commissioners, on Pine Island. Carl referred to his newspaper delivery service as the "dawn patrol," for by 6:30 every morning he was airborne, his single-engine, mono-wing Fairchild humming above the sprinkle of Fort Myers city lights that drifted away behind him at the river's edge. Soon, the scattered lights of farmhouses along Pine Island Road appeared, and Carl began his descent toward Pine Island over Matlacha Pass. At 6:45 a.m., a heavily padded newspaper hit the lawn in front of Harry Stringfellow's screened front porch.

Paper carriers waited on the golf course on Useppa Island and at 'Tween Waters and the Island Inn on Sanibel, looking up when they heard the whine of the plane's engine. Watching the small red and yellow Fairchild emerge from the paling sky, they waited as the plane lowered, banking for the drop, and when the tightly wrapped bundles of newspapers hit the ground, they waved and walked out to retrieve them. Carl's last drop slammed down at Casa Ybel just as the mournful, foghorn call of the conch shell announced breakfast to the resort guests.

At 7:30 a.m., one hour after takeoff, the Fairchild glided in for a noiseless but bumpy landing on the sandy field at the Lee County Airport.

Confirmation

In November 1940, Fort Myers learned that Congress had authorized $40 million for the construction of civil air defense bases nationwide and that the Civilian Aeronautics Administration listed Fort Myers among the twenty-one sites in Florida under consideration for a base. Soon after this news came the announcement that Fort Myers had been designated a national defense project and that President Roosevelt had authorized $128,000 to build two additional runways. The CAA granted another $82,000 to extend one of the runways to four thousand feet and to install

taxi strips and lights. The total WPA workers hired to perform these miracles rose to 145.

No doubt about it: the U.S. Army was headed to Fort Myers. Whether they intended to use the airport as a pilot training field or a bombardier base was still the question, but who cared? They were getting a real airport, and the government was paying for it.

Waiting

They waited for an answer all winter as the pickaxes of the WPA workers rose and fell with the monotony of slow-tolling bells.

Happy Easter bells brought people flocking to their churches, the women in white gloves and dresses as colorful as Easter baskets, the men with freshly barbered hair and shoes flashing Sunday sunshine, and still they waited.

In June, with the last *thring* of school bells, the children of Fort Myers stampeded into summer, into the hot, buttery popcorn aroma of the Saturday morning matinees, into the sandy lots where baseballs smacked hot leather, into the sandy-footed jukebox swing at the beach where Tommy Dorsey's "I'll Never Smile Again" drifted with the aroma of sizzling hamburgers and onions far out over the sun-sequined water.

And work at the airport meandered along. Men snapped open newspapers to follow Germany's advances across Europe and into Russia, they noted the establishment of air raid warning posts in Lee County, and still no word from the army as to what that slow-building airport out there was going to be. If anything.

Summer-warm autumn brought football games and backyard Halloween parties lit with paper Japanese lanterns, kids bobbing for apples in aluminum washtubs and chasing in rubber ghost and gorilla masks through neighborhoods whose every porch light was lit and mothers waited with platters of warm cookies and caramel apples.

In November, women leaned over newspapers on their kitchen counters, comparing prices advertised for turkeys and hams, canned cranberries and jars of spiced peaches, and in December, they pulled down the dusty boxes of Christmas decorations, the bottoms of the boxes littered with the confetti of broken Christmas balls, small dead bugs and bits of silver tinsel, and one Sunday afternoon the radio programing was interrupted

by an excited newscaster saying that the U.S. naval base in Hawaii had been attacked, that Hickam Field, Honolulu and Pearl Harbor had been bombed by the Japanese at 7:55 a.m. that morning.

Alarms and False Alarms

The mayor called an emergency meeting at city hall. City officials agreed to place armed guards on twenty-four-hour duty at the city gas and water plants, an action that elicited somewhat withering scorn from a *News-Press* reporter.

On December 13, the *News-Press* reported that the CAA agent at the airport weather station had become "temporarily unbalanced mentally," claiming that he had overheard six men plotting to blow up the airport and that a "mysterious airplane" had been circling overhead. He had called the Fort Myers chief of police, the CAA office in Atlanta and President Roosevelt, demanding action. Police officers lured him to the county jail and slammed the doors on him.

Waiting

In January 1942, Fort Myers learned that the army had rejected the Lee County Airport as a defense project. They had chosen, instead, a rural community a few miles east of town called Buckingham. Buckingham would get a gunnery school.

"And what about the lemon in that swamp out there?" demanded at least one angry Fort Myers resident. County commissioners tried to smooth ruffled feathers with assurances that they'd gotten a $750,000 airport for a mere $75,000 (the amount of the original bond issue), and anyway, the overflow of servicemen from Buckingham would be all the town could hope to manage.

Little more than two weeks later, first a U.S. Army and then a Navy officer visited the airfield, and rumors sprang up like crabgrass that Fort Myers was going to get a bombardier squadron, an army *and* a navy air corps gunnery school. The visiting army officer said the completed runways were adequate to withstand the weight of twenty-five-ton bombers, and city officials quickly assured him that Fort Myers could provide immediate housing for 250 officers.

Moving Heaven and Earth

In February, they were certain that they were getting a bombardment squadron. The army had leased land south of the airport for tents to house 2,000 men. Now Fort Myers had to move heaven and earth to get ready for them. Contractors were hired immediately to clear 320 acres south of the airfield between the railroad tracks and the Tamiami Trail, to build an entrance road onto the airfield from the Trail and to lay foundations for sixty-one buildings, including barracks, mess halls, administration and utility buildings. The *News-Press* carried ads for carpenters, plumbers and roofers. Airborne civilian pilots witnessed a Lilliputian swarm of 250 laborers over the airfield.

On March 3, 1942, the first U.S. Corps of Engineers officers arrived for both the Buckingham and Fort Myers bases, establishing themselves at the Bradford Hotel. The civilian engineers made their headquarters in the Earnhardt Building across the street.

Three weeks later, an advance unit of one hundred soldiers arrived. As workmen out at the airfield were still putting the canvas tops on the screened tents, sinking wells and laying pipes into mess halls and bathhouses, these advance troops were put up at the fairgrounds out at Terry Park. They bunked in the exhibit buildings and showered in the ballplayers' showers. Cooking was al fresco under the long shed that Commissioner Alvin Gorton used for his annual community fish fry.

Within a week of their arrival, the school board considered initiating a series of school lectures for eleventh- and twelfth-grade girls on the "facts of life." With thousands of soldiers moving into Fort Myers and Buckingham, school officials agreed there was a "serious need for such a program."

Trains, Trucks and Traffic Jams

On March 29, at 10:00 a.m., the first troop train, pulled by two locomotive engines, came whistle-screaming into the ACL station. At 1:30 p.m., a truck convoy crossed the Edison Bridge and proceeded with the deafening noise of heavy engines and grinding gears and the rattling of truck beds down First Street to Cleveland Avenue and out the Tamiami Trail to the airfield. Cars and trucks pulled to the curbs in town, and people came from their businesses out onto the sidewalks to stare, waving at the troops

Atlantic Coast Line Railroad station today, recently vacated by the SWFL Museum of History. *Courtesy Bernard W. Moore, photographer.*

bouncing and swaying in the backs of the trucks. Some of the soldiers grinned and waved back.

They were the Ninety-Eighth Bombardment group from Barksdale Field in Shreveport, Louisiana. The combined total of arrivals that day was 650. The next day, three more trainloads arrived at both the Seaboard and the ACL stations.

Suddenly, the Tamiami Trail was jammed with army trucks and jeeps running men and supplies from Terry Park and the train stations to the airfield and with the trucks and automobiles of people trying to get into the base to witness the event. The army had to send out an armed military guard to keep the civilians off the road into camp.

These first arrivals were ground troops, quartermaster supply and repair groups. With the fliers would come maintenance, radiomen, navigators, engineers, bombardiers and gunners. Workmen were still frantically throwing down tent floors and sodding between runways when the first ground troops arrived, slogging through sand and stumbling over palmetto roots with heavy duffels on their shoulders. Some of them were disgruntled with accommodations that all too accurately simulated combat conditions.

Others were excited to find themselves at last in the mythical land of eternal sunshine.

Over the next week, young officers continued to arrive, those with wives driving their own automobiles, others coming in by train and bus. Single men took rooms at the Bradford, the Palm, the Morgan and the Franklin Arms. Others went to the chamber of commerce to sign up with the hastily organized rooming bureau for rental houses or cottages. Housing rates had been capped for these soldiers, the mayor stating flatly that Fort Myers would not tolerate war profiteering and hotel proprietors and landlords would not get rich off these soldiers. The maximum rate allowed for officer housing was capped at thirty- to forty-five dollars a month and at twenty to twenty-five dollars a month for enlisted men with families.

On August 21, the Royal Palm Hotel opened out of season for the first time in its history. Dr. Marshall Terry's second wife and widow, and now the owner of the hotel, had leased it to a new manager, who threw open the windows and began repairs and renovations to ready it for occupancy by young officers and their families. Rather than the former rate of twenty dollars plus per day, the rooms were rented to the young officers for two dollars per day, twelve months a year, for the duration of the war.

During the first week of April, command headquarters at the airfield was a madhouse, with officers in and out reporting for duty, maintenance men stringing telephone wire, supply men unpacking big maps and plumbers wrenching the last pipe fittings into place. As in frontier Fort Myers in 1850, enlisted men were hacking and wrestling up palmetto and pine stumps, dragging and chopping felled pines for stove fuel and, in their off-time, pitching horseshoes, killing rattlesnakes and chasing, or being chased by, razorback hogs. They dragged a gator out of a drainage ditch and made a pen to keep him in, but the gator played possum until dark and then climbed over and out of the pen.

In the meantime, the airbase commanding officer would not answer the persistent question: "When will the planes arrive?"

Here They Come!

The B-24s came in over the Gulf on Friday, April 3, thundering over the barrier islands of Sanibel, Captiva, Boca Grande, Useppa and Estero and over the frantically waving passengers on the ferry between Punta Rassa and Sanibel Island.

B-24 Liberator. *Courtesy USAAF.*

The following day, the B-17s, coming down from McDill, passed over the river. China teacups, suspended from hooks in china cabinets, tinkled as the shadows of the bombers flowed over the city. Women flew out of their houses, screen doors slapping shut behind them, to stand with heads dropped back and hands over their eyes, and men leapt to the windows of their offices and shops. Children, stilled in their play, gazed up at the stately passage of the big ships with glory eyes.

The next day, at 9:00 a.m., buses, county and private trucks and passenger cars lined up on the Trail at the entrance to the base, waiting to take any men who wanted to go to the church of their choice for Easter services. Members of each congregation had volunteered also to take soldiers home with them after church for Easter Sunday dinner. Mothers admonished their teenage daughters *(for the umpteenth time, Mama)* to behave themselves like ladies, while the girls with trembling fingers and racing hearts dabbed face powder on their noses. Fathers warned squirming little boys not to pester the soldiers—"Don't crowd them now, Son"—but the boys already had their baseballs and mitts, their balsam-wood fighter planes and little tin submarines ready to show.

Jewish men were invited to a fish fry Easter Sunday at Terry Park, and colored soldiers were invited to tea at Miss Ella Mae Piper's home in

B-17 Flying Fortress.

Safety Hill. Miss Ella, a successful businesswoman, respected by the white community and loved by her own, and one of the few women (others were Mina Edison, Clara Ford and Florida Heitman) in Fort Myers who rode in a chauffeur-driven automobile, undoubtedly warmed the boys' tea with something more nourishing to the soul than tea leaves.

Ten days after Easter, the men out at the airfield experienced their first tropical Florida downpour. It broke over them like water from a dam. The sheer weight and rush of the water almost carried away command headquarters. Their eyes flooded, the men worked blindly to sandbank the walls of the flimsy building. And then, as if someone had turned off a bath faucet, it stopped. Slopping in wet sand back to their quarters, the men discovered that they had neglected to let down the side flaps on the tents, and their bedding and personal belongings were soaked. Magazine cutouts of Betty Grable and Rita Hayworth floated, smiling, across the floors of the tents.

Hidden History of Fort Myers

May I Have This Dance?

A *News-Press* editorial warned citizens not to start "yapping" about the noise of the planes day and night. Remember this is war, they were told (not for the last time), and "if one of them should swoop down between your house and the one next door, you can put it down as an exercise in strafing the enemy."

The warning was unnecessary. Grateful for the promised flow of additional revenue into the city and eager to perform its patriotic duty to the servicemen, Fort Myers embraced the opportunity to serve them as warmly as a mother folding a son to her bosom.

The speed and efficiency with which civic organizations, churches and men's and women's social clubs organized off-base housing, transportation, entertainment and recreation for this onslaught, virtually overnight, of thousands of air corps men was astonishing. Before the first troop train pulled into the ACL station, a recreation committee of local church and club women had organized an ongoing program of nightly entertainment at the municipal Pleasure Pier on the river.

The city pier extended nearly 700 feet out over the river. At its head, a massive, richly ornamented white stucco pavilion, with 30-foot domed towers, arose like a Moorish palace in Mediterranean Spain. Fronted by a cloistered arcade, the 70- by 110-foot pavilion contained a central auditorium seating seven hundred people. A canopied terrace graced either end of the auditorium on the second-floor level, and along either side of the pier, an 8-foot-wide canopied walkway, with benches, extended the length of the driveway to the pavilion.

Since its erection in 1927, the Pleasure Pier had been the beating heart of the city, its community ballroom and little theater a stage for musicales, benefits and concerts. Here, jazz-age kids had slammed the ballroom

The Pleasure Pier, 1927–43. *Courtesy waymarking.com.*

110

floor with the Charleston and the Black Bottom, the Camel Walk and the Chicken Scratch, and Paul Whiteman had conducted Gershwin's crashing "Rhapsody in Blue."

Here, too, the Glee Club performed, garden clubs staged flower shows and the Fort Myers High School girls' basketball team played championship games, their rubber-soled shoes squeaking on the polished floor. And here, for the first time, on Friday, April 3, 1942, Fort Myers girls slow danced in the arms of soldiers to Glenn Miller's "Moonlight Cocktail."

The weekly dances for the soldiers began at 9:00 p.m. with the playing of the National Anthem. The recreation committee had invited two hundred local girls who were over sixteen to act as hostesses at the dances. Only soldiers who received dance tickets dispersed by an airfield officer and only the girls signed on as official hostesses were permitted to attend. The girls met their chaperones at city hall and proceeded with them to the function, which ended promptly at 11:00 p.m. with the playing of "God Bless America."

Later referred to as "military maidens," the hostesses would join invited servicemen not only for dances but also for the swim and skating parties, picnics and other social occasions planned by the committee.

Buckingham Army Air Force dance. *Courtesy SWFL Museum of History*.

Edison Home, 1949. *Courtesy State Archives of Florida.*

The men who did not get tickets for any given occasion went to town. Unfortunately, the first contingent of air corpsmen hadn't been paid in three months. Most of them were dead broke. The first weekend, some of them had to walk the four miles into town, where they hoped to get some "jawbone," or credit with the local merchants. Downtown merchants, not to mention landlords, were considerably relieved when the first payroll checks arrived on April 17.

Not that the men needed much money. Like fond parents anxious to please, Fort Myers did its best to offer free, continuous entertainment. In the city park, the recreation committee had set up a temporary little servicemen's club with ping-pong, card and billiard tables. Counted among the recreational facilities ready for immediate use were the city park's shuffleboard courts (in which the soldiers showed little interest) and the park's two cement tennis courts, as well as croquet, roque and horseshoes. The city had also just finished two new clay courts at the yacht basin and intended to provide there also buckets and tennis balls for diamond ball.

The Knights of Columbus offered free ping-pong, billiards, dancing and refreshments nightly, and St. Luke's Episcopal Church provided singing and dancing, darts, ping-pong, punch and cookies.

The Lions Club had regular "smokers" or barbecues, and clubs like the Daughters of the American Revolution and the Elks Club invited the men to fish fries out at Terry Park.

Movie theaters let the men in for twenty-five cents, but if a guy could point to himself in a *News-Press* photo, management let him in free.

Individual citizens continued to invite churchgoing soldiers home with them for Sunday dinner (and games of catch with the kids), beach residents took them fishing and Mrs. Edison, chauffeured out to the airfield, invited

boys home with her for cards and refreshments. Some went without a clue as to who she was.

Trucks ran men out to the beach. They roughhoused with one another in the sand, chased laughing girls into the sea and pushed nickels into the jukeboxes to keep the platters tumbling and "Deep in the Heart of Texas" quick-clapping to the deafening accompaniment of beer bottles rapping sticky tabletops.

In September, a taproom opened in the resurrected Royal Palm Hotel, and like a damaged bomber "coming in on a wing and a prayer," the fragile old structure trembled with the drummeling drums of Glenn Miller, with the Lindy, the jitterbug sling and the stomping, boogie woogie shag.

Rooms that had quietly hosted ladies' bridge parties and piano recitals now filled with the sound of ice cubes dropped into highball glasses, with slow curling cigarette smoke, the sinuous tones of the clarinet and a shrieking sax.

Remembering Channing

World War I aviator Channing Page.

The soldiers out at the airfield had, with wry humor, named their new post "Palmetto Field." The first camp correspondent to the *News-Press* made the name unofficially official by titling his column "Air Base Notes from Palmetto Field."

Within a month of its occupancy, however, the American Legion proposed to the county commission that the air base be named Channing Page Field. Channing Page, a local boy who had been the first Floridian to enlist in the army air corps when the United States entered World War I, had come home with the Distinguished Service Cross and the Croix de Guerre, only to be killed scarcely a year later while attempting to land his charter seaplane on the Barron River in the Everglades.

On May 21, the new name for the airfield was approved.

Page Field Heroes

The flying- and ground-operations training at Page Field was the last six weeks of training men received before deployment overseas. Among the first graduating class in mid-May was a special task force handpicked by the base commander, Colonel H.A. Halverson, to carry out a special assignment known as the Halverson Project, or Halpro. The Halpro unit was sent in June to North Africa to destroy the Axis ships supplying Rommel, field marshal in command of the German campaign in North Africa. Their bombing raids on the Italian supply ships in the Mediterranean and on oil fields in Romania were credited with the ultimate defeat of Rommel's army. Page Field had its first war heroes.

The following month, the officers and crew of a B-24 flying out of Channing Page Field became Fort Myers's first resident heroes when they spotted a German sub in the Gulf of Mexico, came in low as the U-boat crash-dived to escape and dropped two 325-pound depth charges fore and aft of the ship, exploding the sub out of the water.

B-29 SuperFortress.

Buckingham Army Air Force gunnery training. *Courtesy SWFL Museum of History.*

While the bomber crews were training in the air, the ground troops at Page Field received training in airdrome defense. Airdromes in combat zones overseas were subject to attack, so kitchen and supply personnel, maintenance and repairmen were trained in emergency vehicle dispersion, gas attack defense and weapons firing.

Weapons training was conducted off base, as well. On April 25, the *News-Press* reported that Bonita Beach would be used that day for machine gun practice. Firing would be at the water from the ground and from jeeps and trucks. Boats were warned to keep at least five miles out. No shrimp, fishing or pleasure boats were sunk off Bonita Beach that day, so it may be presumed that all commercial and recreational boaters read the newspaper that morning before casting off.

Citizens were also warned to stay away from Buckingham's gunnery school bombing ranges out in Immokalee and over a broad sweep of the Gulf from south Fort Myers beach to north Marco and back.

(Between 1942 and the end of the war in 1945, Buckingham Army Airfield would train forty-eight thousand gunners for long-range bombers. Much larger than Page Field, it encompassed 6,500 acres, 228 barracks buildings, 7 mess halls, 24 hospital buildings, 1 hangar and 6 runways and, at its peak, housed approximately sixteen thousand men and women; it was the largest flexible gunnery school in the nation.)

Presumably, citizens of Tampa were warned of the Civilian Air Patrol raid on that city on September 27, in which two hundred planes of CAP flour-bombed the entire residential and industrial sections of Tampa. The dozen light planes that made up the Fort Myers contingent targeted Ybor City. One can only imagine the devastation; the mind veers from the image of city streets and rooftops, gardens and yards littered with thousands of burst paper bags, of colored streamers dangling from trees. The sheer tonnage of flour, turning to paste in an afternoon rain shower, horrifies.

Pitching In

In addition to baking cookies and frying fish for the soldiers, lending their daughters as dancing and skating and swimming partners and taking the men fishing, the people of Fort Myers did everything they could to support the war effort generally. The Fort Myers Shipbuilding Company turned out barges for the navy. Women, working forty-five-hour weeks in an assembly-line tent factory in east Fort Myers, turned out one hundred tents every twenty-four hours, for an average income of four dollars a day. On designated days, movie theater owners accepted scrap metal as the price of admission, and members of civic clubs like the Kiwanis took turns selling war bonds in the movie theater ticket booths. Lee County

also organized scrap-metal cleanup days. Housewives and schoolchildren were enlisted in the campaign to collect not only scrap metal but also any household items they could spare that were made of rubber and fabric. Heavy pieces of metal were picked up by civilian and army trucks and loaded onto gondolas at the Monroe Street railway siding for shipment to Birmingham foundries.

In return for the patriotism and hospitality of Fort Myers's townspeople, the soldiers staged song and dance acts on the Arcade Theater stage or in the rec hall on the base to which the public was invited, free of charge. These shows were not hopelessly amateur, as some of the men, in civilian life, had been professional musicians, like the first camp bugler who used to play trumpet with Eddie Duchin's band.

When the Lions Club set up a bonds-sale booth at the entrance to the First Street Arcade, the army loaned two jeeps with drivers to give rides to anyone purchasing a bond valued at above two dollars. Barbara Mann, wife of the Lions Club's former president, got the first ride, the driver taking her to the sandy fill below the Gondola Inn on west First Street to hurtle her over an obstacle course of sand bumps and palmetto stumps.

In December 1942, four hundred townspeople attended the al fresco army air force band concert out at Page Field. Half a dozen bombers circled overhead like a merry-go-round as the band played "The Stars and Stripes Forever," and as AT-6 Trainers flew over in formation, the band struck up the Marine Hymn, the sunlight that flashed off their trumpets and trombones, clarinets and baritone horns daggering tears from the eyes of the audience. Then a trumpet trio rocked back on their heels with Harry James's "Concerto for Trumpet" and the band launched into the "Tiger Rag."

In return for glory, Fort Myers gave the men song and flowers, sending the girls' Glee Club, in long evening gowns, out to the base to sing for them and, when asked, sending flowering trees and shrubs out of their own yards for the men to plant around their barracks.

Farewell

Every six weeks or so, when a graduating class shipped out, whole families might gather at the train or bus station to say goodbye. The farewells were tearfully cheerful, the boys hugging surrogate mothers and firmly, with

wide grins, shaking hands with surrogate fathers and making affectionate, teasing shoulder jabs at their new little pals. Amid the hissing release of brakes, the kidding, the pleas and promises to come back after the war flew back and forth. The boys piling into buses hung out the windows, boasting about mopping up Japs and winning the war, and the girls waving goodbye cried. A guy in a cowboy hat leaned down from a bus window to kiss a girl on tiptoe just as the driver ground the gears and the bus lurched forward, jerking them apart.

The Fighters

In January 1943, Page Field became a base for training fighter pilots. To the great Fort Myers airshow of Mitchell B-25s, B-24 Liberators, B-26 Marauders and B-17 Flying Fortress bombers were added, over the next two years, P-39 Aerocobras, P-40 Flying Tigers, the Lockheed P-38 Lightning, the P-47 Thunderbolt (with eight wing-mounted .50-caliber machine guns) and the P-51 Mustang. The pilots advanced, over from sixty to ninety hours of aerobatic-, gunnery- and formation-flight training, from basic trainers to AT-6 Texans to the fighter planes.

Inevitably, pilots and their crews were killed in training. Civilian "crash boats" worked with the coast guard out at the beach to recover crash survivors or bodies. A light bomber crashed off Sanibel Island in January 1943 with one survivor rescued and two lost; one body was never recovered. On March 2, a lieutenant was killed making an emergency

Republic P-47 Thunderbolt. *Courtesy USAAF.*

North American P-51 Mustang.

AT-6 Trainer planes.

Lockheed P-38 Lightning.

landing at Page Field, and in the same month, over a period of three days, in two separate midair collisions of bombers, sixteen were killed. In the first week in November, over two days, two pilots were killed in separate crashes in the woods north of Bayshore Road in North Fort Myers.

Occasionally, the pilots survived. One lieutenant crash-landed in shallow surf at the beach. A couple of trucks pulled the plane out and towed it back to Page Field. Another bailed out of his fiery plane over the woods along Pine Island Road. He spread out his parachute and built a fire as a beacon, but it was a couple of days before search planes located him.

Year Two

Into the second year of base operations, Fort Myers's enthusiasm for entertaining and mothering the Page Field boys remained undiminished. Terry Park had been appropriated by the Fifty-Third Flight Group of the Sixth Air Force, which had organized four baseball teams to play teams from the gunnery school at Buckingham. The Fort Myers gun club hosted

shooting competitions between Page Field sharpshooters and gun club members. Officers played golf with the country club set at the Fort Myers Golf & Country Club on McGregor Boulevard, and in the Singer sewing shop downtown, women sewed chevrons on sleeves and patched fatigues while the guys waited in their skivvies. When the base asked for cane and bamboo fishing poles so the men could go fishing, the poles stacked up at the chamber of commerce in the Collier Arcade.

In the summer of '43, mosquitoes hatched in such overwhelming numbers that, like attentive parents, Fort Myers people worried about the effect on the fliers. "I don't know how those boys see where they are going," one citizen told a *News-Press* reporter. "They must fly by instruments by day as well as night. I know they couldn't see very far through all those swarms of mosquitoes.

"Those propellers have to chew their way through, the mosquitoes are so thick. If you are standing behind them you can see the path they cut—just like a round auger hole."

In October 1943, with a grant from the Federal Works Project, the city opened a new servicemen's recreation center in the city park opposite the yacht basin, using, as they were wont to do, salvageable materials from the demolition of historic structures—in this instance, the Pleasure Pier, built in 1927. Condemned because the pilings were "rotten," the "hulking" (as some described it) old pavilion and auditorium had been demolished but for a portion that was lifted and moved to the park to serve as a small ballroom. The rec center also had game and reading rooms, a kitchen and a shower.

In the balmy winter season of 1944, the nondenominational Chapel by the Sea on Captiva Island invited enlisted men to get-togethers over coffee and donuts, providing transportation from Page Field that included a ferry ride from Punta Rassa. Conversation with the Sanibel Island girls was most pleasant, especially as the one-room, white-frame church stood very near the beach and the gentle wash of waves along the shore seemed just outside its open windows.

In winter, also, drunk with the fragrance of blossoming orange trees, many a young man married "the girl back home," who came to Fort Myers to wed her fiancé before he shipped overseas and met him at the altar in creamy satin or in a traveling suit with a corsage of gardenias trembling on her breast.

A Mother's Lecture

Glamorous combat pilots, in their uniforms and dark glasses, worried not a few parents of young girls in Fort Myers. After October 1944, parents could remind their daughters of the "tragedy" of the automobile accident that "took the young life" of a girl who was out "where she should not have been, doing what she should not have been doing."

Sisters, seventeen and twenty-two years old, who worked in the Blossom pinball amusement center on Hendry Street, had left work one midnight at closing in the company of a twenty-four-year-old Page Field pilot and a civilian flight instructor from Carlstrom Air Field in Arcadia. "Apparently, these four young people went to the beach, after *midnight*, mind you," a mother might say, with drawling insinuation, "because coming back to town on *McGregor Boulevard*, at 3:00 *a.m., Sunday* morning, the car, which was, as I recall from the newspaper, a 1937 Ford sedan, left the road *at a very high rate of speed* and *hit a Royal Palm tree*. Now, I don't know because I wasn't there, but it's a pretty safe bet that those young people had been drinking. The boy driving probably passed out for all I

Pilots in training at Page Airfield, 1940s. *Courtesy Base Operations, Page Field.*

know. Well, you know what they say…the Lord looks out for drunks and fools. That automobile cut that tree in half, and the front folded up like an accordion, and mind, not a person in that car was hurt except for the older of the sisters, who was pitched *over the head of the driver head first through the windshield.*" A prolonged silence would follow this statement, during which the daughter might begin to nibble at the rough skin at her nail edges. *"They say she never regained consciousness."*

That summer, however, soldiers had saved the lives of two girls at the beach. Pulled out to sea by a strong tide and high wind, the frightened girls had called for help, and the two enlisted men, both radiomen, swam strongly out to the young women and brought them to shore. One of the girls, possibly legitimately, required mouth-to-mouth resuscitation.

Year Three

All through the summer of '44, as Allied forces battled their way from the body-strewn beaches of Normandy into France, Fort Myers continued to cater to the needs of its Page Field boys. Mable Willoughby, as post librarian, opened an air-conditioned library on base in mid-July. Homey with a mantel clock and a record player with classical music phonograph records, the library stocked an impressive number of books (over 2,500), as well as magazines and periodicals.

Servicemen also took advantage of the opportunity to take mechanics, science, mathematics, typing and business English courses at Thomas A. Edison College, a junior college that opened in 1941 on the lounge and dance floor of the Town Club.

On a hot summer day in June 1944, the boys put on a parade downtown to help sell war bonds. As the vehicles of local dignitaries and base officers, jeeps, police car and fire engine and marching soldiers wound through town to the stirring marching music of the Buckingham gunnery band and the Page Field orchestra, fighter pilots staged a flyover of fifty planes. The formation was reported to have taken fifteen minutes to pass over the town. War bond sales that day totaled $161,000.

Germans Land at Page

On February 13, 1945, a pair of trousers was found in east Fort Myers at the corner of Edgewood and Sutton. "PW" was painted in black on the seat and each leg of the pants. It was assumed that the pants were discarded by an escaped prisoner of war, but Lee County had no POWs—at least, not yet.

Over the course of the war, 378,000 (some say more) Axis prisoners of war would be held at military camps across the United States. Some 10,000 Germans would be held in Florida. Of these, 25 of an eventual 225 POWs arrived at Page Field on February 17, 1945, where a barricaded area had been prepared for their living quarters. Some of these prisoners would be contracted out by the army to local farmers, who were short-handed because of the draft. Others were put to work digging drainage ditches. Until the postwar practice of mosquito control through ground and aerial spraying of pesticides, draining standing water from fields and swampy areas was the most effective method of mosquito control. Mosquitoes were more than an irritant; they were carriers of malaria, a disease that, like epidemic typhus, dysentery and typhoid, posed a greater threat of debilitation and death among army and navy personnel than human enemies.

One Down, One to Go

Germany officially surrendered to the Allied Forces on May 7, 1945. To the citizens of Fort Myers, the news brought a measure of relief, but we were still at war with Japan; our boys were not home yet. Other than a shrilling of the fire station siren, the ringing of church bells and the sounding of car horns, May 8 was just another Tuesday.

The front-page *News-Press* headline on August 15, **WAR IS OVER!**, was another matter. The celebration began at 7:00 p.m. the night before when news of Japan's unconditional surrender came down from Washington to the news services. Fort Myers went wild. Downtown, cars and trucks, overloaded with singing and shouting men and women, teens and soldiers, paraded up and down the streets, horns blasting. Cow bells clanged, tin cans tied to bumpers rattled over the pavement and firecrackers exploded along the curbs. Police, state highway patrol and fire station cars joined in, sirens shrilling. The American Legion's jampacked auto-locomotive rollicked along, bell clanging, and two boys on a cow pony dodged in and out of the

mêlée. Soldiers burst into the *News-Press* offices in the Collier Arcade to get autographs on that afternoon's extra announcing the surrender. The bars closed immediately following the announcement, but people passed around bottles of their own stash.

The next day, all offices, schools and stores were closed. All morning, the civilian and military people and vehicles making up Fort Myers's victory day parade gathered at the yacht basin under a broiling sun (murderous to those with hangovers). They were more or less in position when, at 11:00 a.m., the drum major of Buckingham's 649th Army Air Force Band put his whistle between tight lips, filled his lungs and blew. The bass drum boomed, brass horns swung up and with the militant rattling of snare drums and the clash of cymbals, Fort Myers's Victory Day parade began.

Leading the band was the car carrying the mayor and Lee County commission chairman, Harry Stringfellow, and the commanders of both Buckingham and Page Fields. Joining the parade of 1,500 soldiers from both bases, including the Women's Army Corps from Buckingham (who had acted as administrative personnel, orderlies and drivers, radio operators and air controllers, and some of whom had piloted the planes towing the flexible gunnery targets), were American Legion veterans, Veterans of Foreign Wars, the fire chief's car and a fire truck, a Red Cross car and a group of Florida cowboys on horseback. At the seemingly endless passing of troops, the townspeople and soldiers mobbing the parade route screamed and clapped, especially when a number of navy men, home on furlough, fell into line with the army. Smoke bombs tossed from a jeep kept the already hysterical kids hopping and squealing. It was a glorious day.

And when it was over, the general feeling, aside from joy, pride and gratitude, was that Fort Myers was going to be mighty lonesome when the boys left.

Departure

Both Buckingham and Page Airfields were scheduled to be deactivated by September 30. All month, the troops were pulling out by the hundreds every week from the Seaboard and ACL train stations, from the Tamiami Trail bus station; waving at tearful landlords, they were pulling away from the little houses and apartments they had rented, they were checking out of the battered hotels they had caroused in. On September 30, as the last

AT-6 Trainer at Base Operations, Page Field, today. *Courtesy Bernard W. Moore, photographer.*

couples were carrying their luggage to their cars, staff were shutting down the kitchen and the taproom of the Royal Palm Hotel.

On Monday, September 10, sixty fighter planes lined up for takeoff at Page. One by one, the engines vibrated, the propellers whirled and the wheels began to roll, and one by one, the P-40 Warhawks, the P-47 Thunderbolts and the P-51 Mustangs lifted from the runways, their wings flashing as they banked northeast and away.

At the end of the month, only an AT-6 trainer, a P-51 Mustang and a C-45 courier transport remained at Page Field; 140 maintenance and administrative personnel also remained to dismantle and pack up the remaining equipment.

The date and time that the last military vehicle drove out the base entry road and turned right onto the Tamiami Trail is not recorded.

Recovery

As the city streets emptied, gradually, of army air force uniforms and trucks and jeeps, people's minds and eyes cleared; the passions of war,

the glamour, hardship and uncertainty of wartime living had simply evaporated. It was over.

Fort Myers was on its own again. Recovery from the initial shock of abandonment was rapid. October is actually the ideal time for the army to leave, city boosters thought. It gives us time to regroup, to get promotional campaigns going to bring back the tourists. Time to sweep up, so to speak, and get the house ready for the "season." After all, with an end to gas rationing and restrictions on train travel, people will be planning their first vacations in years. Industry will be putting rubber and metals back into civilian car manufacture because people are as starved for new cars as they are for steaks and butter and sugar.

Yessir. The army has cleared out not a minute too soon. Time to get to work.

Part VII

Out with the Old, In with the New

Fort Myers readied itself for a population explosion. Page Field had reverted to Lee County and become the Lee County Page Field Airport, and National Airlines returned with six daily arrivals and departures of potentially new residents.

Without a trace of sentimentality for the past (like their parents and grandparents), and more eager to build than at any time in their history, this new generation of Fort Myers citizens immediately began sweeping out the old to make room for the new.

The first to go was the decrepit, half-century-old Royal Palm Hotel. Always inclined less to aesthetics than to practicality and profitability, the city deemed "worthless" the once elegant resort that had drawn to Fort Myers many of its early builders and entrepreneurs. The buildings, promenade dock and swimming pool were demolished in 1948, and a Gulf Oil gas station went up on the site at the corner of First and Fowler.

At first, Fort Myers grew, not explosively, but steadily. Subdivisions of new, concrete-block, ranch-style homes began to spread in every direction. These modern homes featured terrazzo floors and jalousie windows, pink or turquoise appliances and bathroom fixtures, chrome and plastic dinette sets and no-frills, hard-angled furniture. They were sleek and sophisticated, perfect for hosting the cocktail parties that were all the rage after the war. Much more so than the jazz-age generation of their parents, these thirty-something veterans of both the Great Depression and the Second World War enjoyed their highballs and flirtations and dancing in dinner jackets

Above: National Airlines plane at Page Field, 1950s. *Courtesy Base Operations, Page Field.*

Right: Construction at the former site of the Royal Palm Hotel today. *Courtesy Bernard W. Moore, photographer.*

and cocktail gowns. They had survived, and they were still young, but if they were going to make up for lost time, they had to get on with it. Besides, the babies were coming fast.

To attract conventions and to have a proper venue for swank affairs, Fort Myers built itself a new civic center in 1955. The concrete, steel and stucco auditorium boasted nearly ten thousand square feet of ballroom, an arched roof allowing for thirty-nine-foot-high ceilings, a twenty-five- by fifty-two-foot stage, double glass-paneled entrance doors and a large patio facing the river. With its chic interior color scheme of pale greens and pinks and modern fluorescent lighting, it was the city's pride and joy. They named it, grandly, the Exhibition Hall.

Fort Myers's first big shopping center, the Boulevard Plaza, opened in 1960 along the river on McGregor Boulevard. Fronted by an eight-hundred-vehicle-capacity parking lot, its five thousand feet of retail space was anchored by Food Fair and Woolworth's. The Plaza's popularity was short-lived, however. In 1965, the one-half-million-square-foot Edison Mall opened way out on the Tamiami Trail. With forty-six stores, including the first mall store ever opened by the glamorous Tampa-based Maas Brothers chain of department stores, it was a shopper's nirvana.

Billy's Creek today, with TV satellite dishes at left. *Courtesy Bernard W. Moore, photographer.*

Billy's Creek today, entering the river between high-rise condos on East First Street/Palm Beach Boulevard. *Courtesy Bernard W. Moore, photographer.*

A reunion of Company B, 110th Infantry Regiment, circa 1895.

The Edison Mall sucked shoppers and retailers from downtown Fort Myers out the Trail, which now proliferated with touristy motels and family restaurants, drive-in burger joints, filling stations and auto repair garages.

The heart of "old" Fort Myers began to wither.

On Billy Bowlegs Creek, just across the Billy's Creek bridge, WINK-TV broadcast *Gunsmoke* to thousands of children and their parents who had no idea that Fort Myers had ever been a cowboy town of horses and saloons and gunfights, a town where drunken cowboys once rode carousel horses back of a saloon on First Street.

No one disputed the magazine writer who confidently declared in print that "Fort Myers was never really a fort."

The Disorienting Effect of Bulldozers

The soldiers who died at Fort Myers during the Seminole and Civil Wars had been buried at some distance from the fort in the general vicinity of present-day Second and Fowler Streets. Fowler Street was named after Captain W.H. Fowler, whose grave was discovered by road builders in 1885. In 1888, the remains of fifty soldiers buried in the old fort cemetery were transferred to the military cemetery at Fort Barrancas in Pensacola.

The last physical remnant of the fort itself, a two-story wood-frame house, had been disposed of in 1937. Built circa 1850, this house had been the fort's commanding officer's quarters. When Fort Myers was abandoned in 1865, the first homesteaders to arrive on the site, the González family, moved into the house. In it, Evalina González had opened the settlement's first school. Over the years, three more of the pioneering first families of Fort Myers would occupy this house, each making improvements until Harvie and Florida Heitman moved in and made it a Fort Myers showplace.

In 1926, four years after Harvie's death, the Heitman estate moved the house back across Bay Street to make room for the $1 million hotel that the Heitmans, in the spirit of the crazed building boom of the era, promised to

An 1864 officer's sketch of Fort Myers overlaid on a current map of downtown Fort Myers. *Courtesy SWFL Museum of History.*

build there. When that fuse fizzled, the little house was gladly appropriated for use as Fort Myers's first stand-alone public library. In its former location arose Fort Myers's first stand-alone post office, a neoclassic structure of bewildering grandiosity.

Over the next decade, the little shack of a library out back, with its three old-fashioned dormers and a wooden scrap of a front porch, creaked and leaned wearily, its cosmetic of paint entirely washed away. Finally, it was condemned.

Soon after the librarian packed up the books and catalogue files and moved out, a bulldozer bumped up over the curb, shoved its bull-grader blade under the front porch of the house and, grinding its gears into full-forward throttle, began to shove. The structure was over eighty years old, so it collapsed rather easily. No one watched the demolition debris rain into the back of a dump truck, nor did anyone notice the truck drive away with the rubble of the last remaining structure of the fort that had given birth to Fort Myers.

Nevertheless, Fort Myers had its first centennial celebration in 1950 in commemoration of the establishment of the fort that gave the town its name. As the event coincided with the annual Edison Pageant of Light,

Formerly the post office, today the Sidney and Berne Davis Art Center on the site of the former Fort Myers commanding officer's quarters. *Courtesy Bernard W. Moore, photographer.*

a weeklong festival highlighted by the coronation of the King and Queen of Edisonia, it was more a commemoration of Thomas Edison, to whom Fort Myers seemed to believe it owed its existence. Indeed, in honor of the centennial, Thomas Edison's son, Charles, crowned the young "Royals" of 1950 in a brilliant and exclusive ceremony in the Arcade Theater.

Possibly forgetting the first one, Fort Myers had its second centennial celebration in 1985 in commemoration of its incorporation as a town.

Unfortunately, it is too late to have a centennial celebration in commemoration of the arrival of its first homesteaders in 1866. Three centennial celebrations would certainly have set a world record.

But then, the argument over whether to celebrate the bicentennial in 2050, 2066 or 2085 would have to begin immediately.

Bibliography

Abbott, Karl P. *Open for the Season*. Garden City, NY: Doubleday & Co., 1950.

Allman, T.D. "The Truth About Florida's Civil War History." Daily Beast, February 20, 2014. www.thedailybeast.com/articles/2014/02/20/the-truth-about-florida-s-civil-war-history.html?via=desktop&source=email.

Billinger, Robert D., Jr. *Hitler's Soldiers in the Sunshine State: POWs in Florida*. Gainesville: University Press of Florida, 2009.

Board, Prudy Taylor, and Esther B. Colcord. *A History of Aviation in Lee County, Florida*. Fort Myers, FL: Commissioned by the Lee County Port Authority, 1993.

"A Century of Burial Removals at the U.S. Military Cemetery at Fort Myers (8LL1758): Historical and Archeological Perspectives." *The Florida Anthropologist* 49, no. 4 (December 1996).

Cole, David. "Survey of U.S. Army, Uniforms, Weapons and Accoutrements." www.history.army.mil/html/museums/uniforms/survey_uwa.pdf.

Covington, James W. *The Billy Bowlegs' War, 1855–1858: The Final Stand of the Seminoles Against the Whites*. N.p.: Mickler House Publishers, 1982.

Denham, James, and Keith L. Huneycutt, eds. *Echoes from a Distant Frontier: The Brown Sisters' Correspondence from Antebellum Florida*. Columbia: University of South Carolina Press, 2004.

Dyer, Frederick H. "Florida 2nd Regiment Cavalry." *A Compendium of the War of the Rebellion*. (1908). www.civil-war.net/searchdyers2.asp?reg=2nd%20REGIMENT%20CAVALRY&searchdyers=Florida.

Bibliography

Florida Department of State. "Florida in the Civil War." www.museumoffloridahistory.com/exhibits/permanent/civilwar.

Fort Myers News-Press, 1911–70.

Grismer, Karl H. *The Story of Fort Myers*. Fort Myers Beach, FL: Island Press Publishers, 1982.

Hancock, Almira Russell. *Reminiscences of Winfield Scott Hancock*. New York: Charles L. Webster & Company, 1887.

History of the Tamiami Trail, and a Brief Review of the Road Construction Movement in Florida. Miami, FL: Tamiami Trail Commissioners and the County Commissioners of Dade County, 1928.

Jackson, President Andrew. Message to Congress "On Indian Removal," December 6, 1830. Records of the United States Senate, 1789–1990, Record Group 46, National Archives and Records Administration.

Kaufmann, Patricia A. "First Battalion Florida Special Cavalry 'Munnerlyn's Cow Cavalry.'" *La Posta* (First Quarter 2013).

The Past Times. "General William S. Harney, 'The Mad Bear.'" www.fortlincoln.org/uploads/1/0/5/4/10548146/fall_2014_edition.pdf.

Seley, Ray B., Jr. "Lieutenant Hartsuff and the Banana Plants." *Tequesta: The Journal of the Historical Association of Southern Florida* 23 (1963).

Wallace, Fred W. "The Story of Captain John A. Casey." *Florida Historical Quarterly* 41, no. 2 (October 1962): 127–44.

Yarlett, Lewis L. "History of the Florida Cattle Industry." *Rangelands* 7, no. 5 (October 1985). journals.uair.arizona.edu/index.php/rangelands/article/viewFile/11974/11247.

INDEX

A

Alachua 20
Alva 79
Arcade Theater 88, 117, 135
Arpeika. *See* Jones, Sam
Atlantic Coast Line Railroad 75, 93, 94, 105, 106, 110, 125

B

Bank of Fort Myers 62, 70, 80, 81, 86, 97
blockade 39, 40, 50
Blount, Jehu 83
Boca Grande 39, 102, 107
Bowlegs (Bolek, Beaulieu), Billy 20, 21, 22, 23, 29, 32, 34, 35, 54
Bradford Hotel 63, 77, 79, 80, 83, 86, 87, 105, 107
Brown, Harvey 24

Buckingham 104, 105, 111, 115, 116, 120, 123, 125

C

Carson, Frank 13, 71, 82
Casey, John Charles 20, 22, 23, 31
Cattle Battalion 42
cavalry 37, 40, 41
Charlotte Harbor 16, 20, 39, 58
Chipco 23
Civil Aeronautics Administration (CAA) 100, 101, 102, 104
Cowkeeper 20

D

dawn patrol 102
Doyle, James 41
Dunn, Carl 102

INDEX

E

Earnhardt Building 83, 105
Edison, Thomas A. 53, 54, 55, 57, 58, 63, 64, 65, 73, 76, 79, 94, 95, 98, 105, 109, 112, 123, 135
Evans, Edward 79, 82, 83, 88

F

ferry 67, 92, 107, 121
Firestone, Harvey 94, 95
First National Bank 62, 70, 82, 83, 84, 97
Flagler, Henry 78
Florida Airways Corporation 99
Florida Southern Railway 58
Footman, William 40, 41
Ford, Henry 94, 95
Fort Brooke 16, 18, 23, 27, 28, 29, 30, 31, 44, 48, 49
Fort Delaney 48, 49
Fort Denaud 18, 32
Fort Harney 22, 28
Fort Harvie 17, 48, 49
Fort Myers Golf & Country Club 97, 121
Fort Myers Hotel 60
Fort Myers News-Press 13, 100, 102, 104, 105, 110, 112, 113, 116, 121, 124, 125
Fort Myers Press 62, 74, 80, 99
Fort Myers Yacht & Country Club 63, 65
Fowler, W.H. 133

G

Gardner, Bertie 62
González, Evalina 44, 133
González, Manuel 44, 45, 49, 75, 133
Grand Theater 82, 88

H

Halpro 114
Halverson, H.A. 114
Hancock, Winfield Scott 25, 27, 29
Harney, William Selby 27, 28, 29
Hartsuff, George 24, 25, 46
Heitman, Florida 57, 58, 73, 109
Heitman, Harvie 57, 58, 62, 69, 70, 72, 73, 74, 75, 76, 77, 78, 79, 80, 82, 83, 84, 85, 86, 87, 88, 89, 133
Hendry, Francis Asbury 40, 41, 42, 43, 44, 70, 97
Hendry, James E. 43, 70, 73, 75, 76
Hendry, James E., Jr. 96, 97
Hendry, Marion 41
Holata Micco. *See* Bowlegs (Bolek, Beaulieu), Billy

I

International Ocean Telegraph Company 50, 52, 58

J

Jones, Sam 22

INDEX

K

Kissimmee River 31, 39

L

Langford, Nicholas 70
Langford, Taff 80, 83
Langford, Thomas E. 69, 76
Langford, Walter 69, 70, 71, 72, 75, 78, 79, 80, 82, 83, 85, 87, 89, 93, 98
Lee County Airport 99, 101, 102, 104
Lee County Bank 70, 79, 97
Loomis, Gustavus 27, 29, 31, 33, 35

M

Mann, Barbara 117
McDougall, Walt 51, 52
McGregor, Ambrose 55, 56, 58, 62, 63, 73, 75
McGregor Boulevard 63, 67, 94, 95, 97, 121, 122, 131
McGregor, Bradford 55, 63, 75, 76
McGregor, Jerusha (Tootie) 55, 62, 63, 67, 75, 76, 78, 99
Mickler, Jacob 30, 31
military maidens 111
Millionaires' Row 62
Munnerlyn, Charles James 40, 42
Murderers' Row 58
Murphy, John T. 60, 61, 62, 97
Myers, Abraham C. 16, 17, 18

N

National Airlines 99, 129, 130

O

Oconee 20
Olustee 42
O'Neill, Hugh 59, 60, 62, 63, 67

P

Page, Channing 113
Page Field 113, 114, 115, 116, 117, 118, 120, 121, 122, 123, 124, 125, 126, 129, 130
Palmetto Field 113
Parker, Howell A. 69, 72
Parkinson, Edward 79
Peace River 16, 22, 39
Piper, Ella Mae 108
Plant, Henry B. 58
Pleasure Pier 110, 121
POW 124
Punta Gorda 58, 59
Punta Rasca 47

R

Rector, Elias 33, 34
Riverside Drive 57, 63
Rockefeller, John D. 55, 73, 78
Rogers, S. St. George 32, 33
Royal Palm Hotel 60, 62, 63, 65, 78, 97, 107, 113, 126, 129, 130

INDEX

S

Seaboard Air Line Railway 97, 106, 125
seawall 63, 78
Shultz, George 51, 52, 53, 54, 55, 57, 58, 59, 63, 64, 65, 73, 76, 77, 79
Stringfellow, Harry 102, 125
Summerlin, Jacob 38, 39, 44, 50, 54, 67
Summerlin, Sam 54

T

Tarpon House 54, 55, 57, 58, 59, 64, 65, 79
telegraph 50, 52, 53, 55, 65
Terry, Marshall Orlando 78, 107
Terry Park 105, 106, 108, 112, 120
Tillis, Nelson 46
Tillis, Willoughby 46
Towles, Bill (Bulldog) 85, 86
Twiggs, David E. 16, 17, 18, 22, 23

W

Weatherford, John 49
Winder, John 20, 22, 23, 24
Women's Army Corps (WAC) 125
Wood, W.H. 54
Works Progress Administration (WPA) 98, 99, 101, 103
Worth, W.J. 48